MANGA FURRIES COLORING

Talia Horsburgh

COLOR YOUR WAY THROUGH CUTE AND COOL MANGA FURRIES ART!

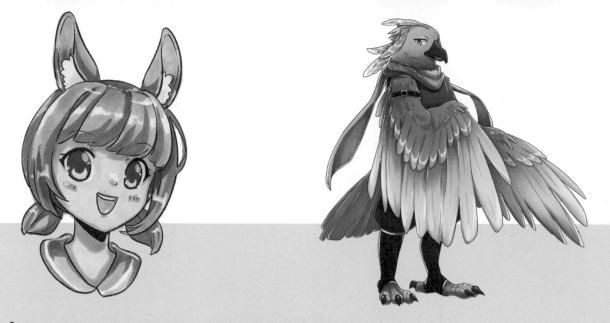

LOVE MANGA FURRIES? *Manga Furries Coloring*

offers a stress-free escape into the creative world of coloring. Manga lovers of all ages will enjoy using colored pencils, markers, and crayons to color a selection of manga characters and scenes from artist Talia Horsburgh, including kimono (humans who possess animal-like features), kemonomimi (largely animalistic), scalies (reptilian and amphibian creatures), unique fursonas, and more!

ABOUT THE ARTIST

Talia Horsburgh is an Australian illustrator known commonly online by her internet alias Orbitalswan (@orbitalswan). From humble beginnings tracing anime DVD covers on her bedroom floor as a child, to completing a bachelor of fine art at the Queensland College of Art in 2016, Talia has a passion for creating and teaching art. She has taught drawing workshops to teams from notable companies such as Google, YouTube, and Pinterest. Talia is the author of *The Art of Drawing Manga Furries*, has been featured in various magazines, and was recognized "Best in Western Talent" by *NEO* magazine.

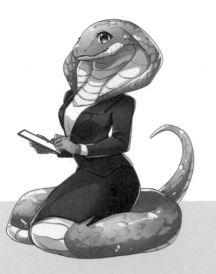
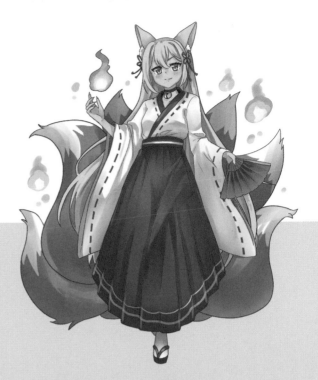

TOOLS & MATERIALS

COLORED PENCILS: Keep colored pencils sharp to create fine lines and broad strokes. They give you a good amount of control over your strokes; the harder you press, the darker the line. You can also use an eraser to tidy up your lines.

CRAYONS: Crayons are a playful, inexpensive way to color your drawings. These wax-based tools have a soft feel and provide quick, textured coverage.

MARKERS: Bold, crisp, and rich in color, markers generally come in three types of tips: chiseled (wide and firm), fine (small and firm), and brush (soft and tapered).

ADDITIONAL MATERIALS: Try using ink pens, gel pens, paint pens, and more to create different coloring effects. Experiment to find your favorite coloring tools. The sky is the limit!

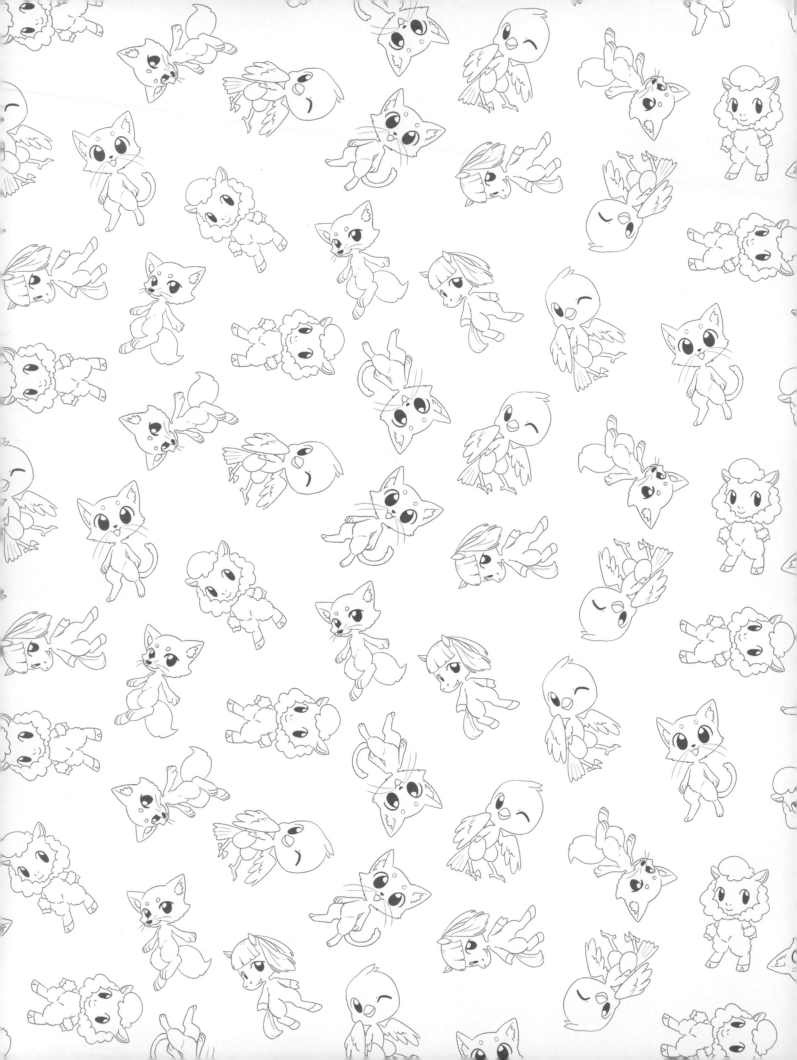

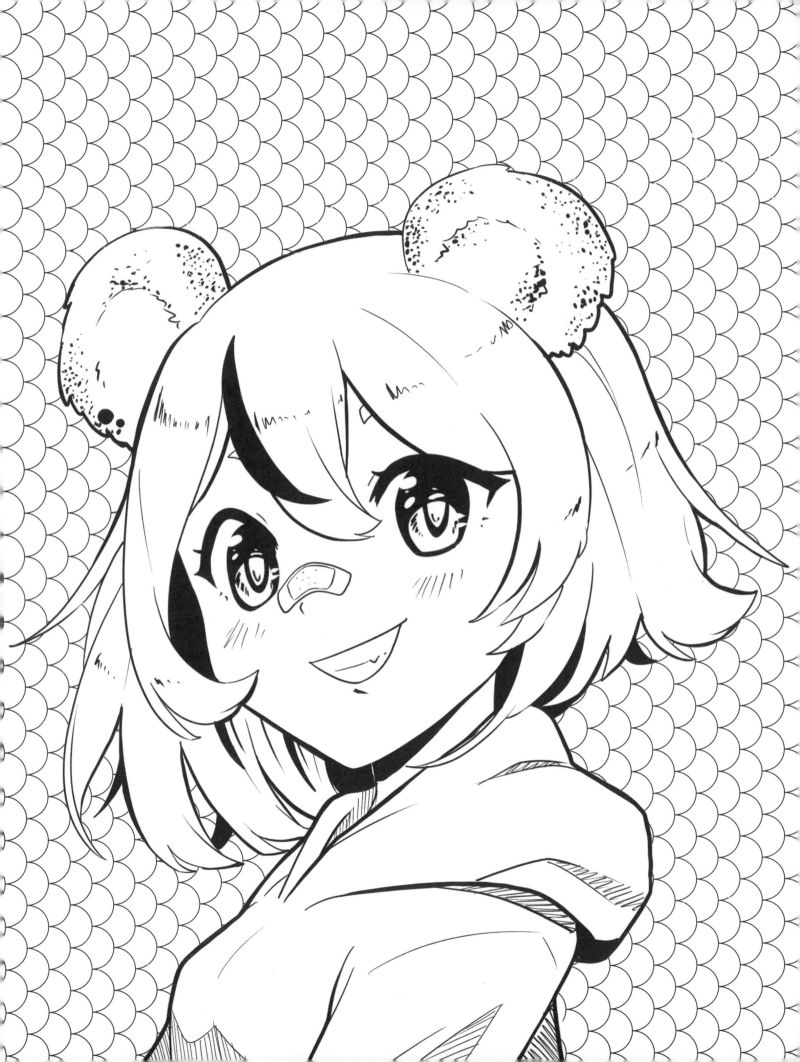

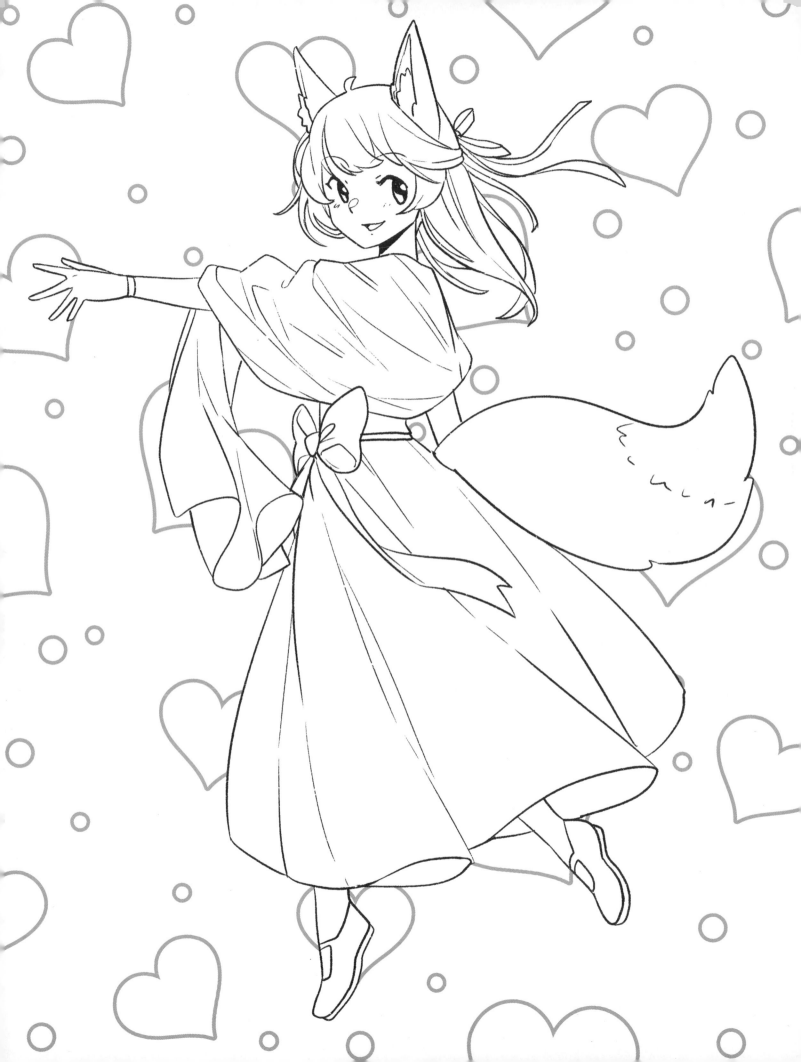

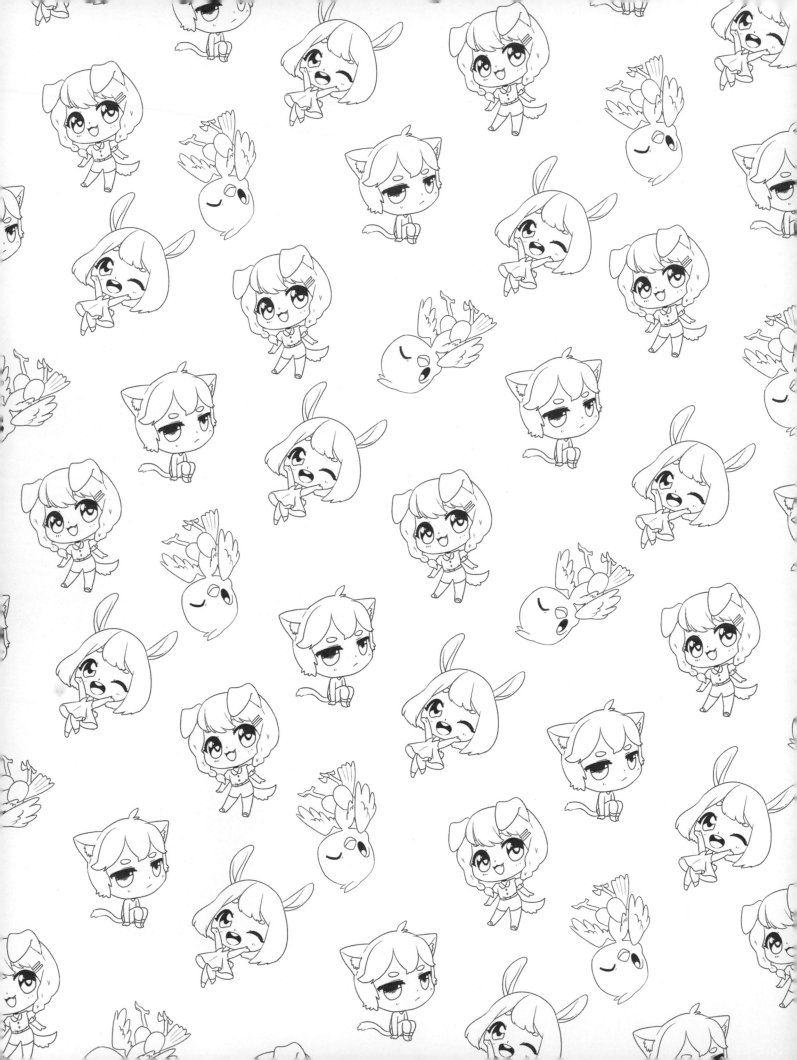

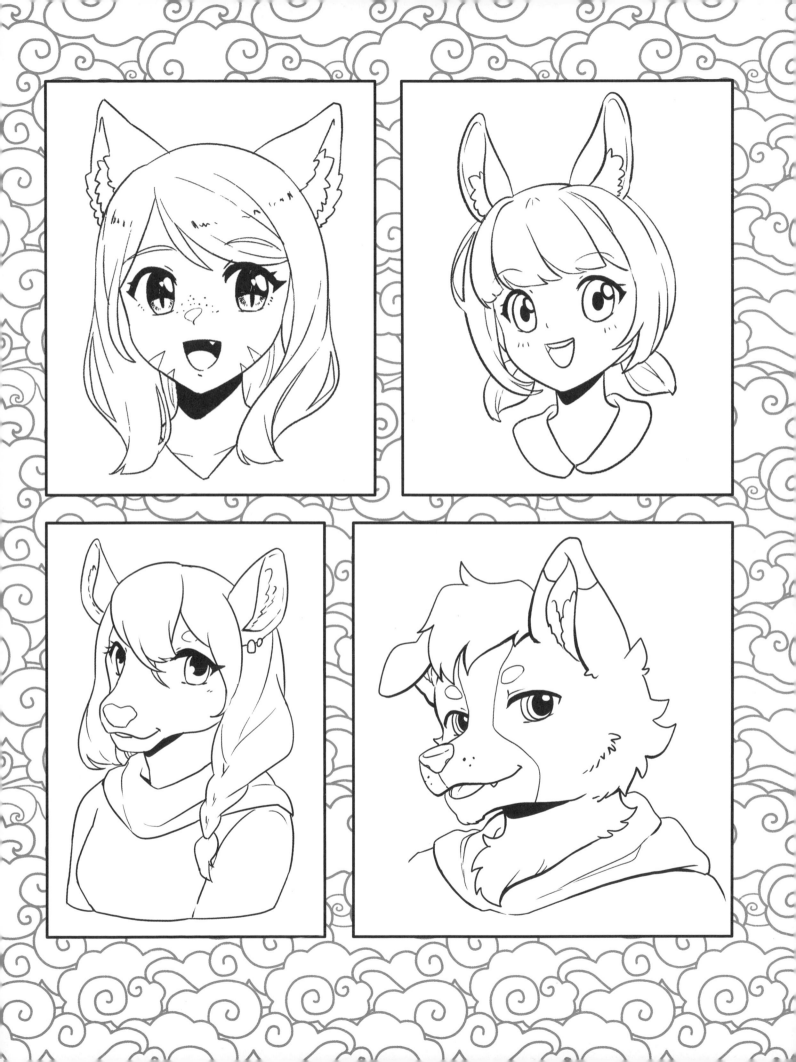

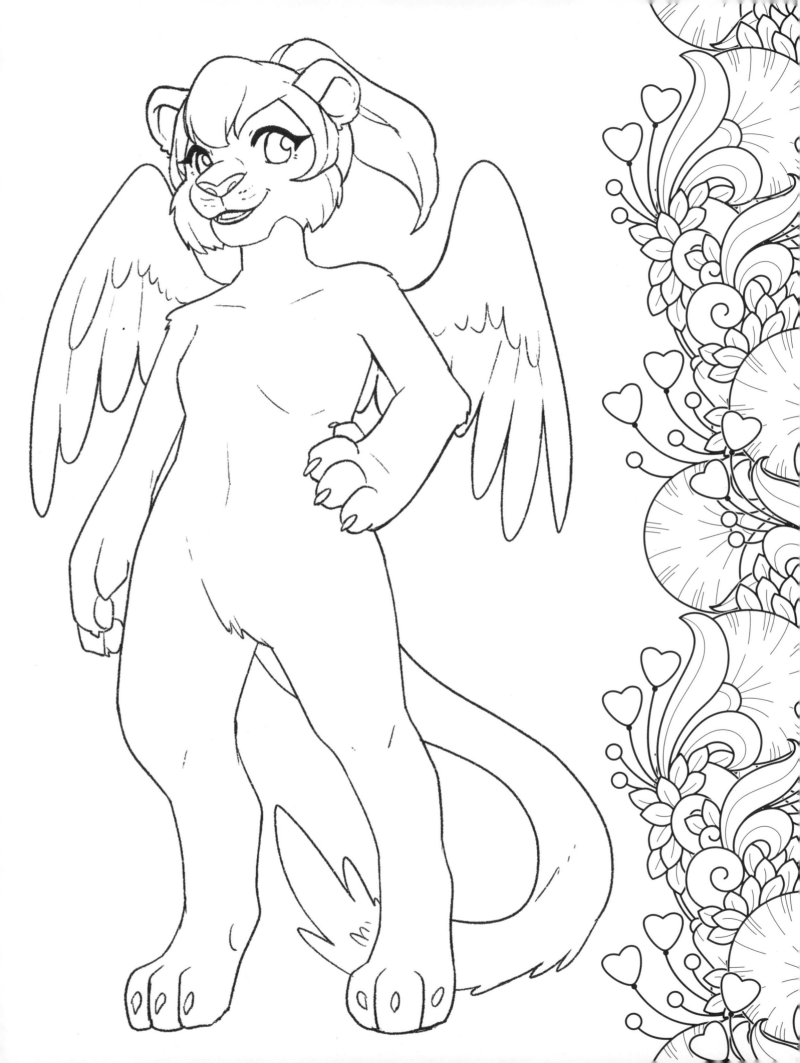

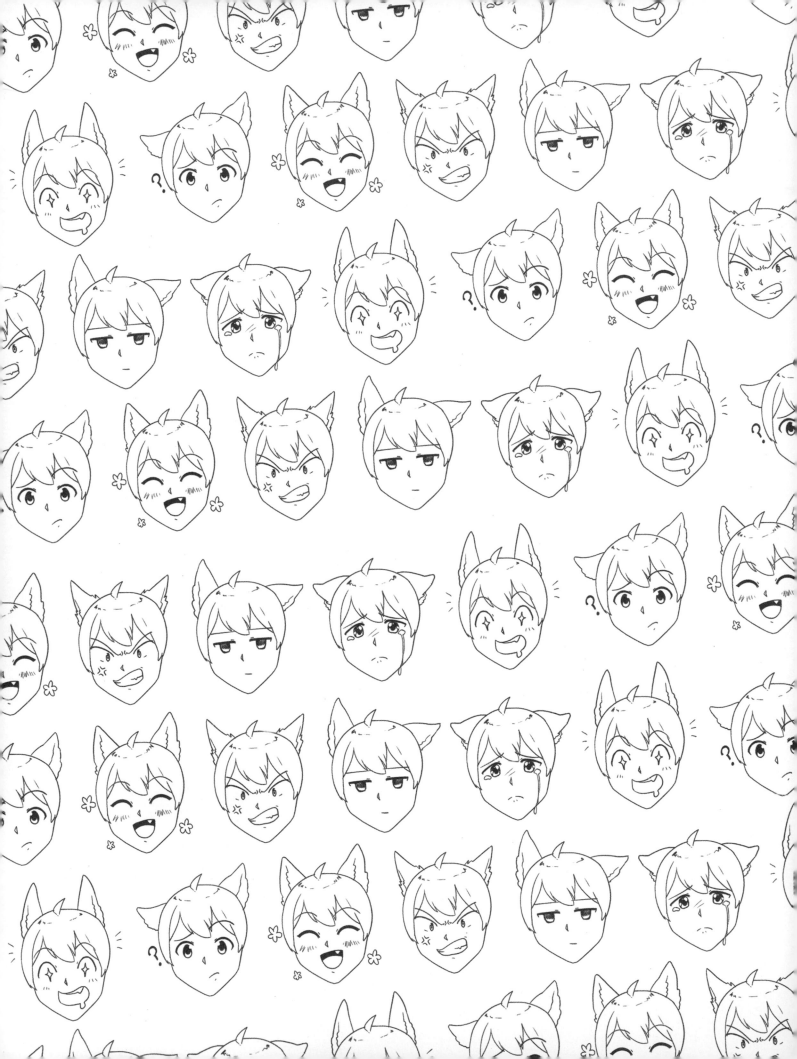

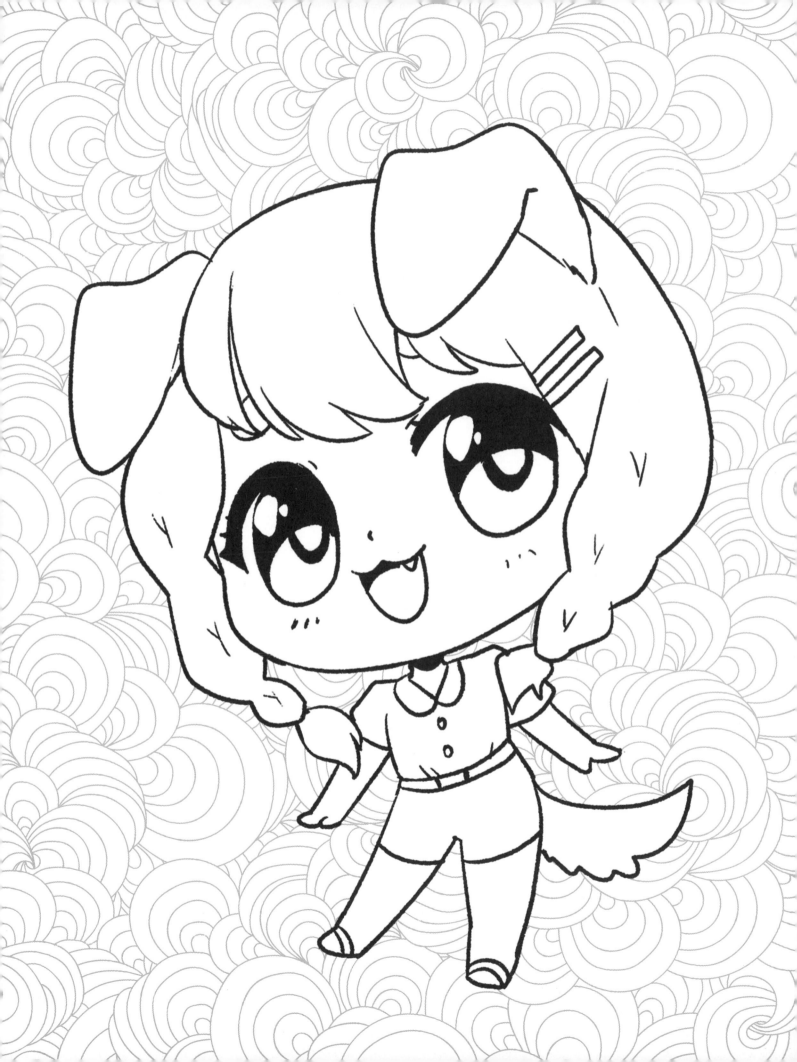

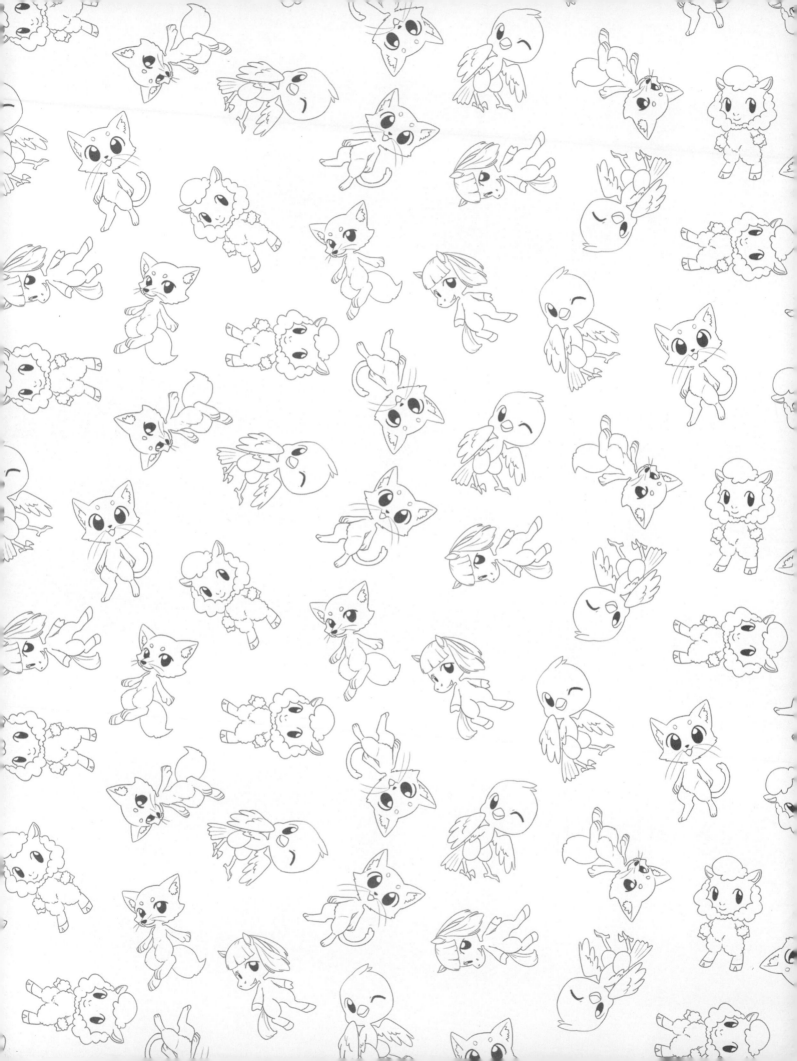

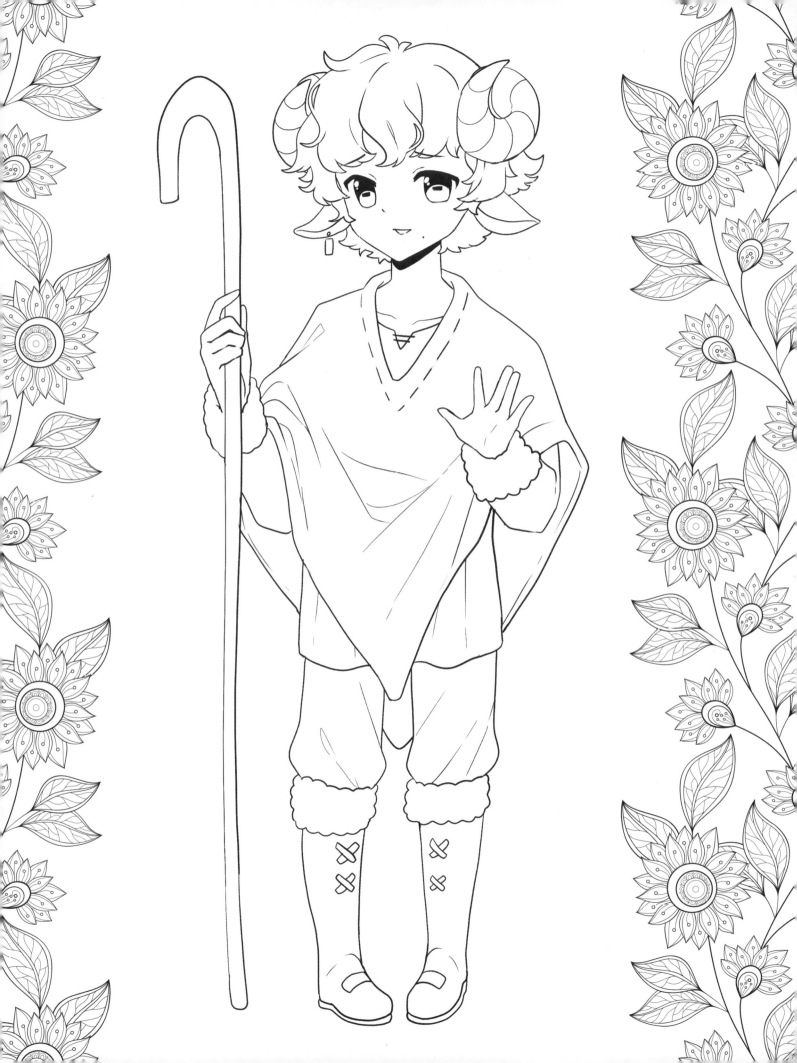

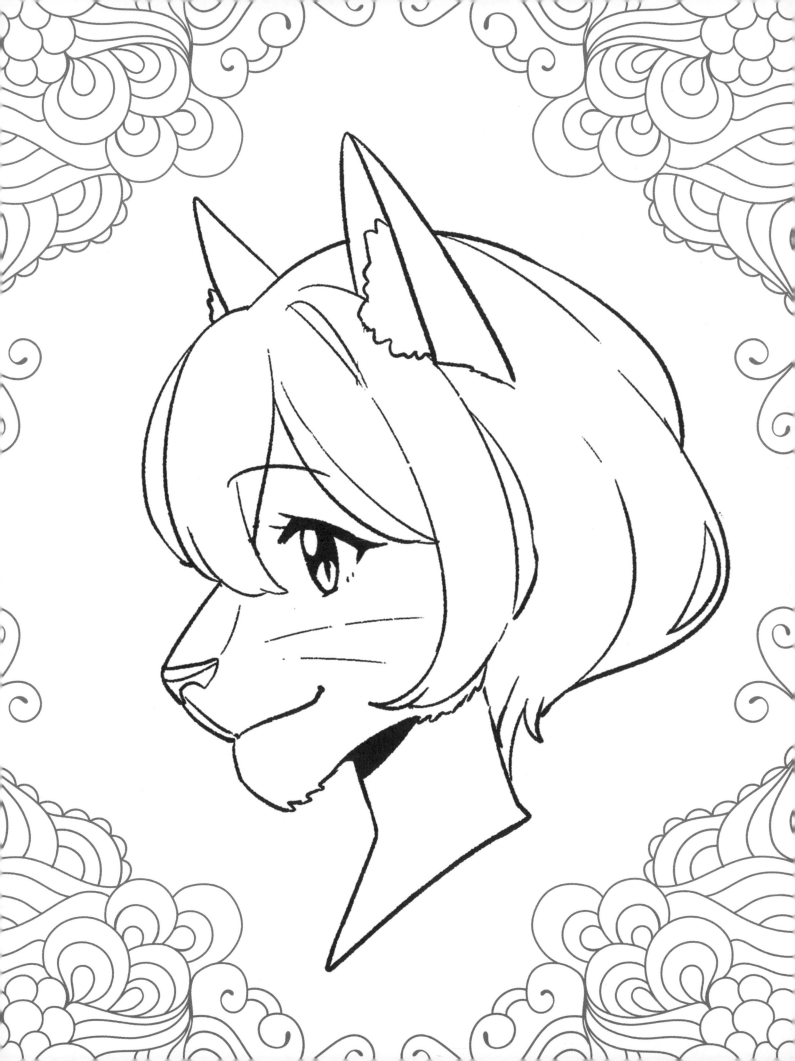

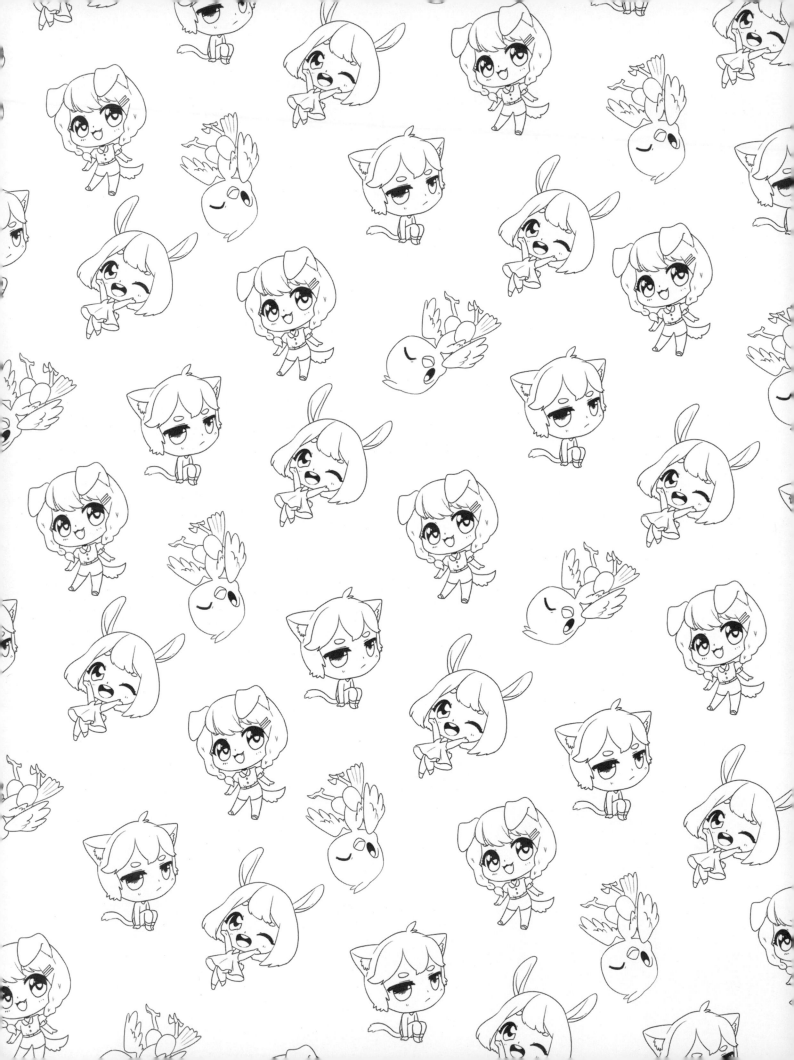

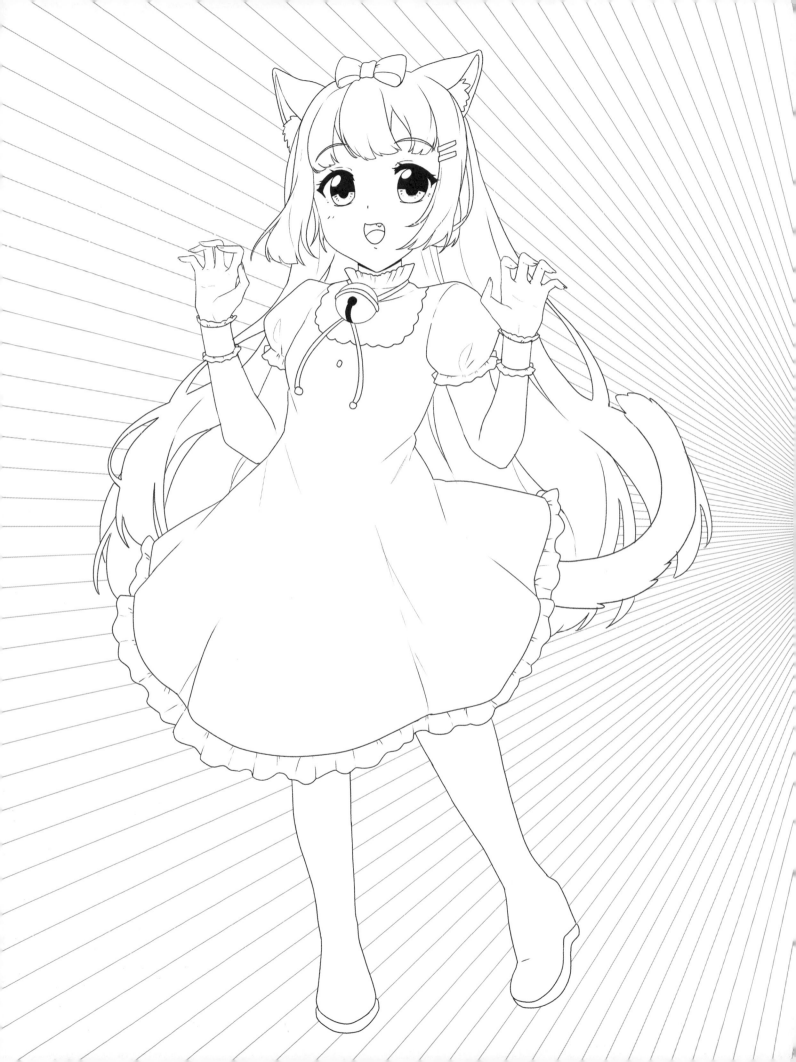

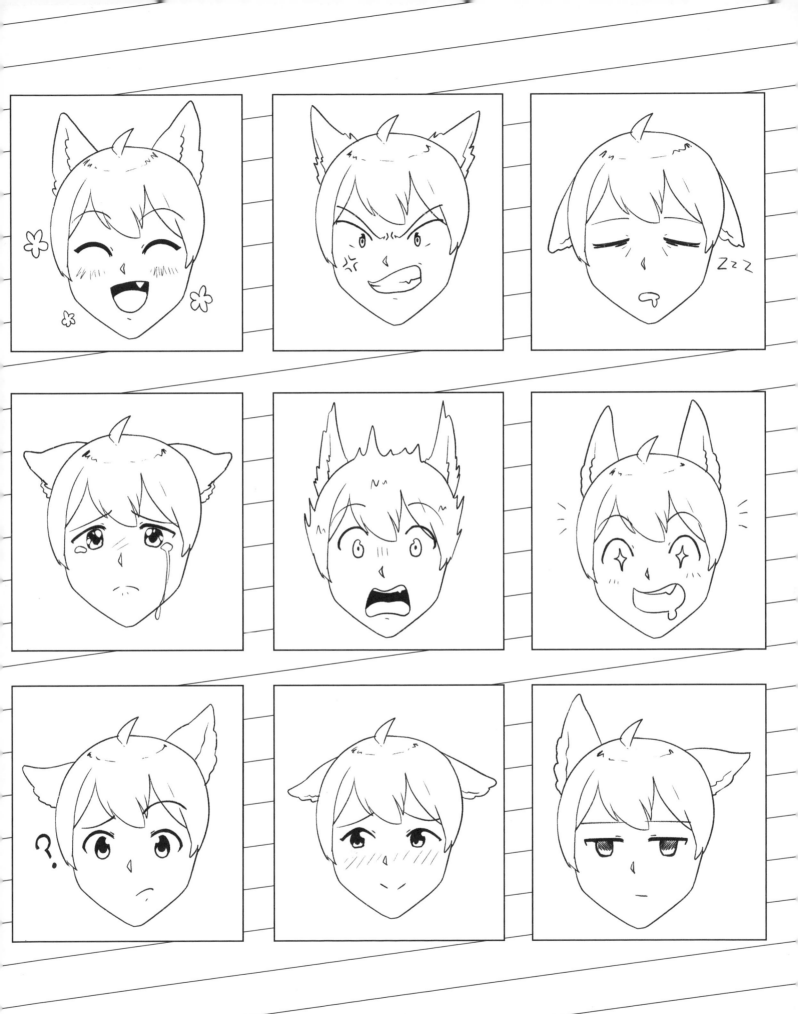

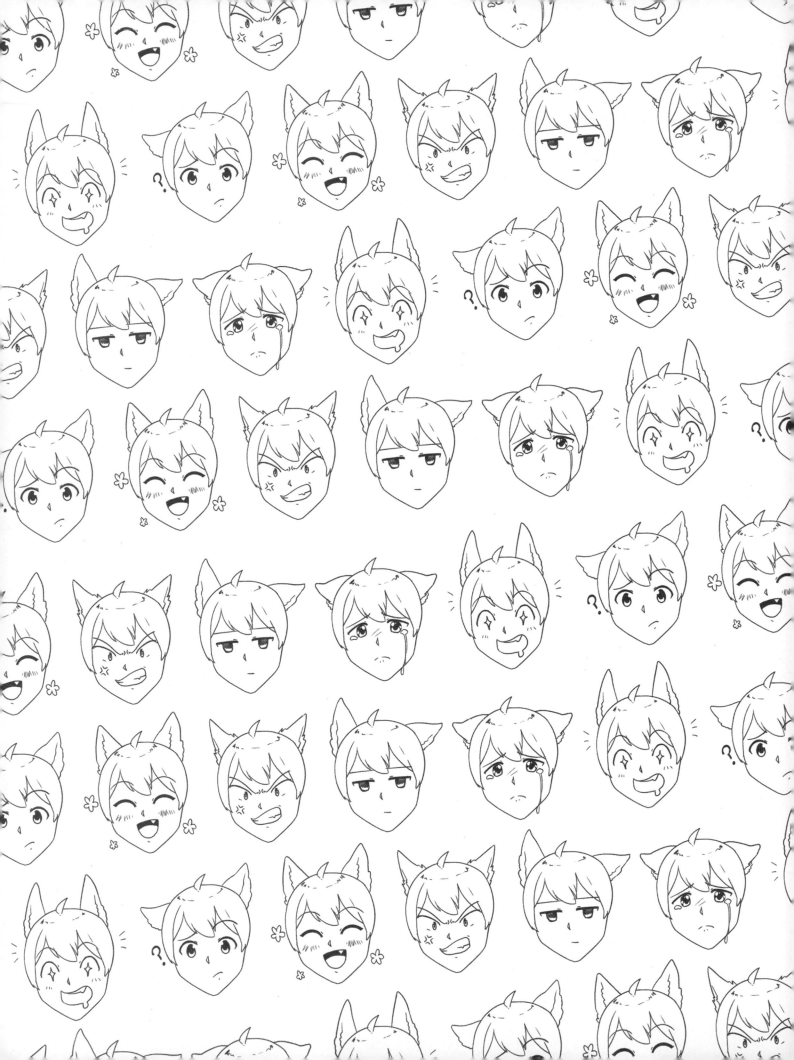

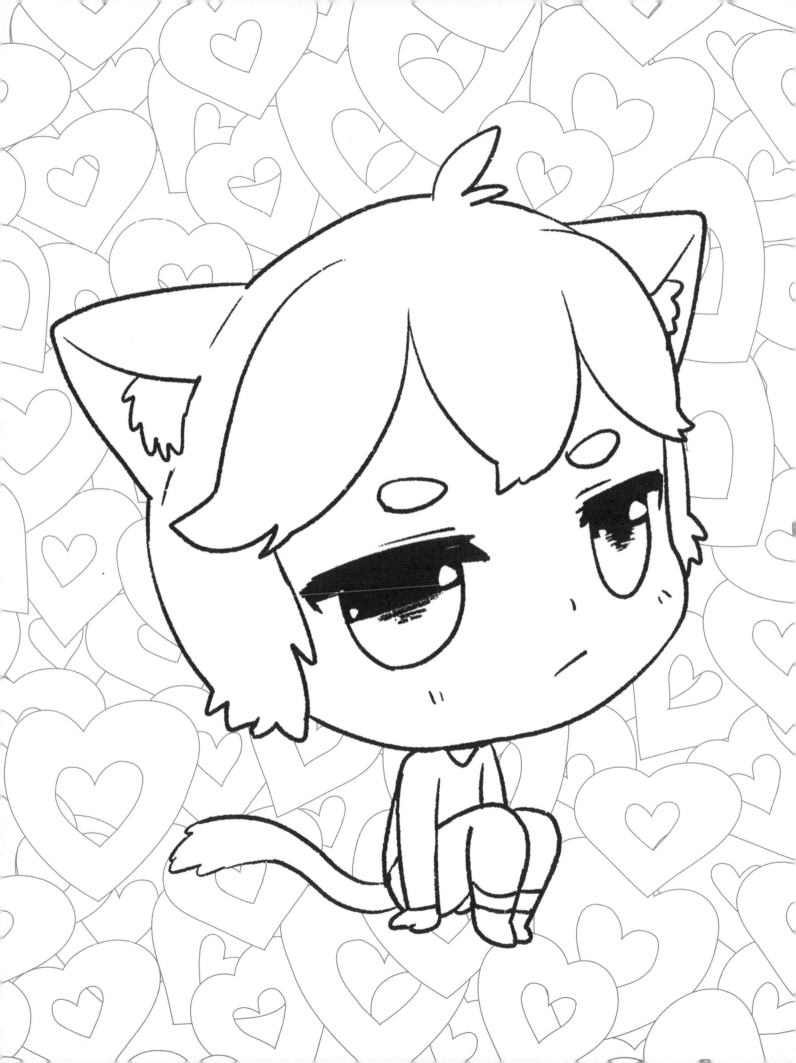

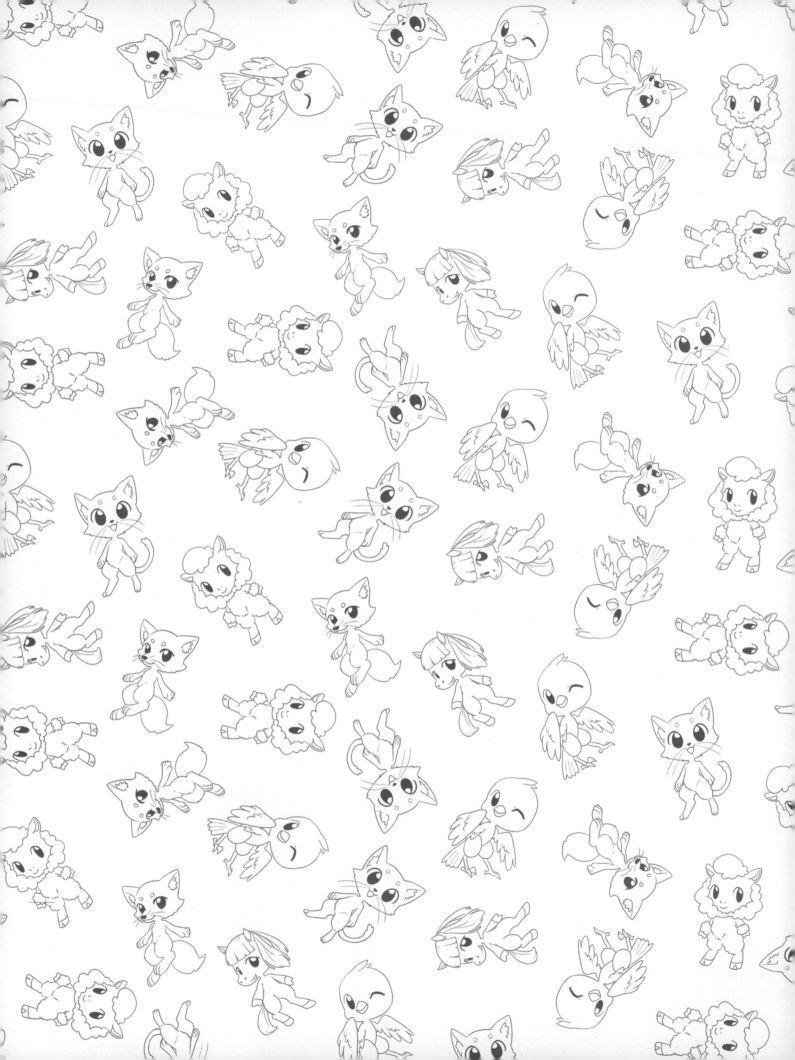

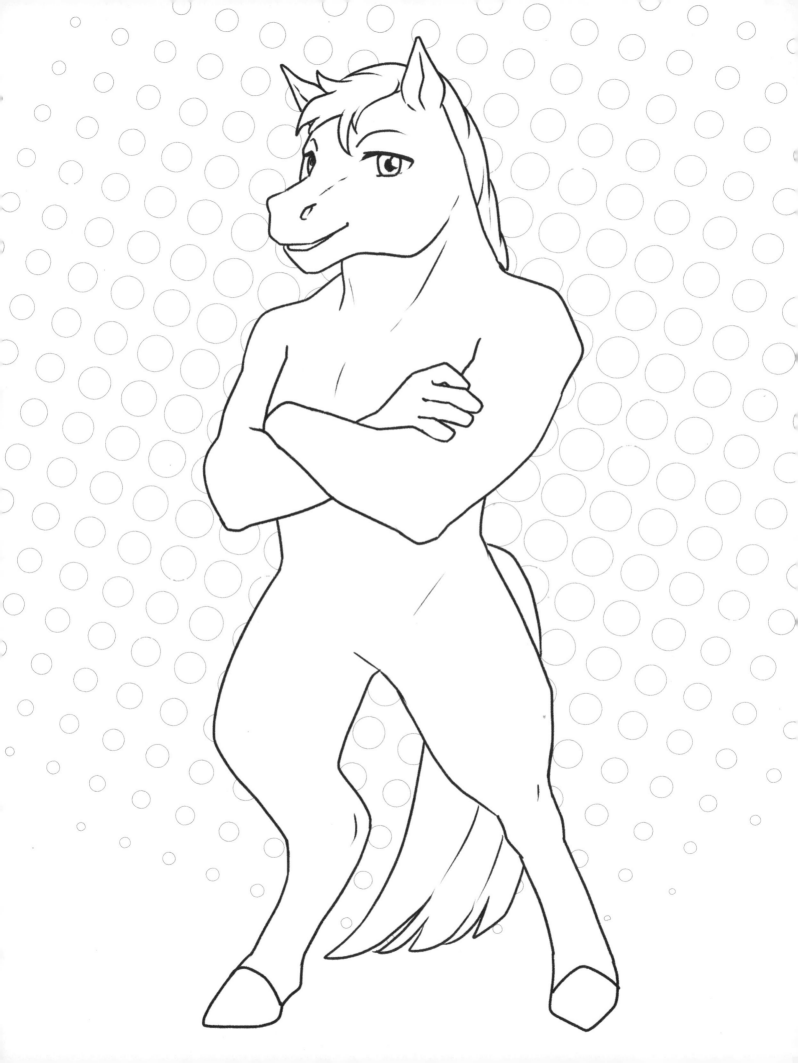

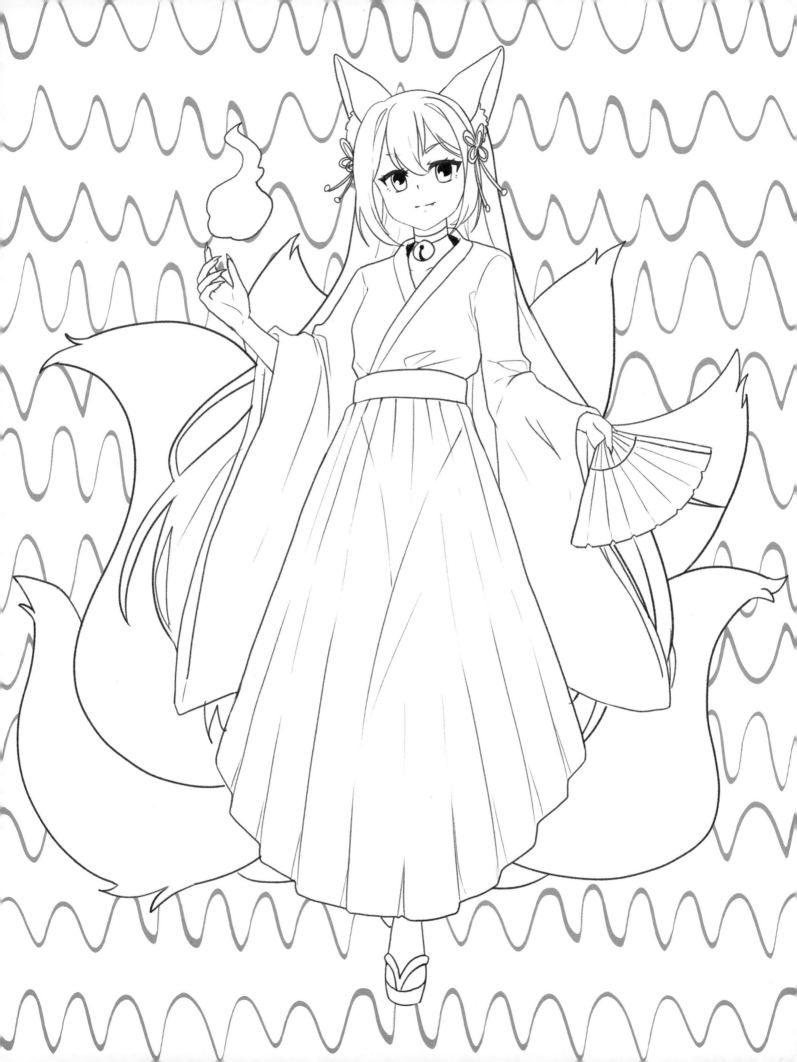

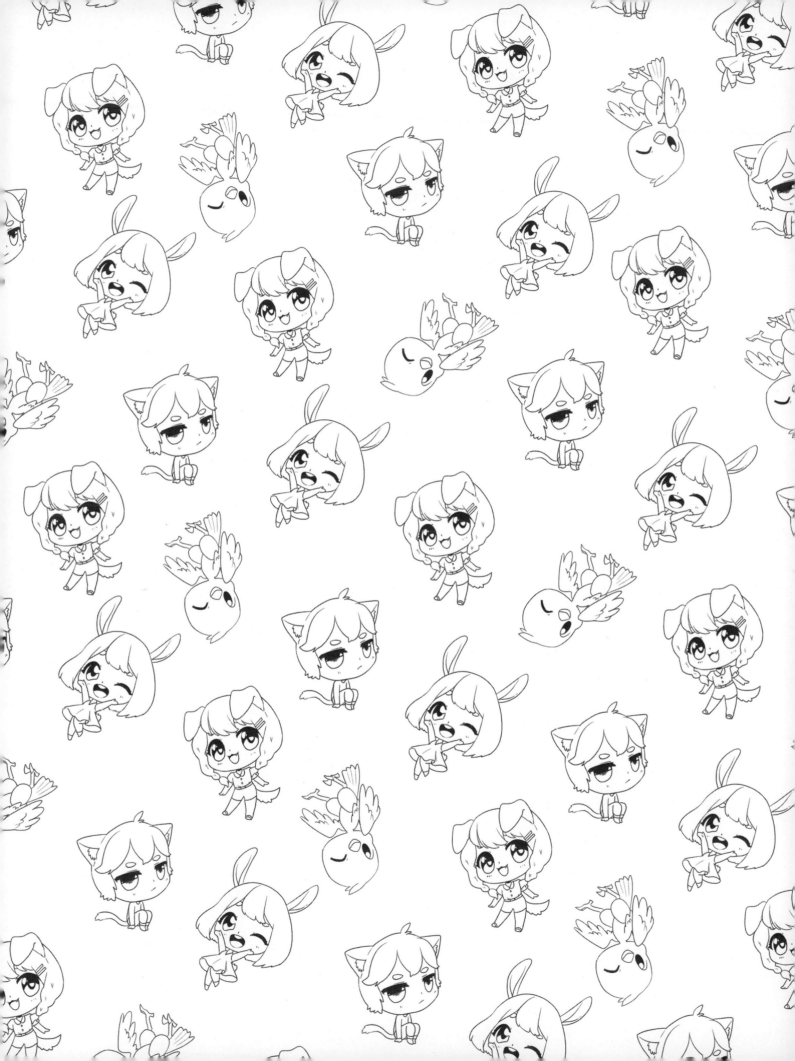

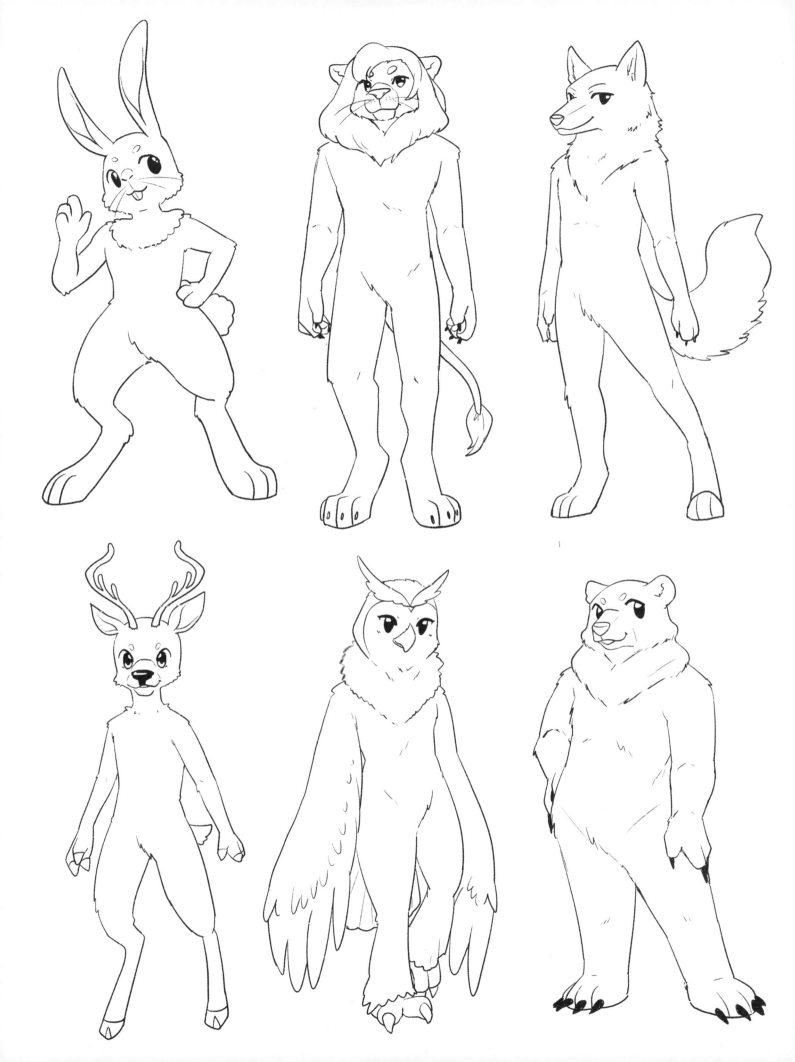

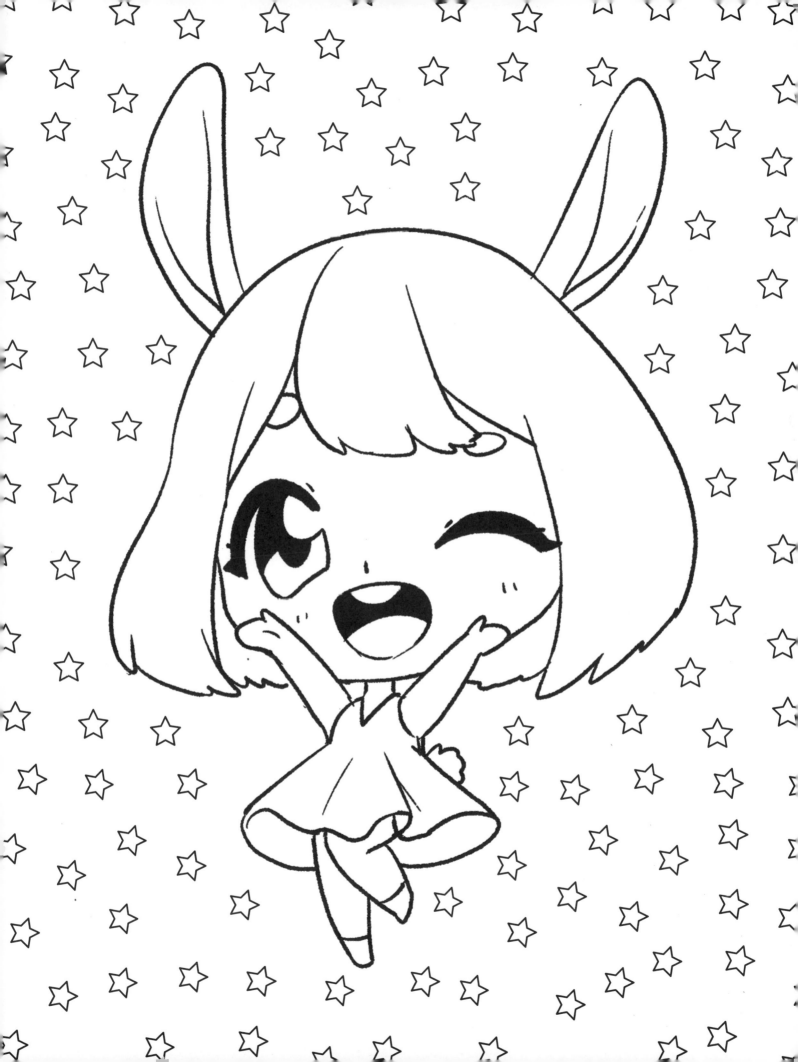

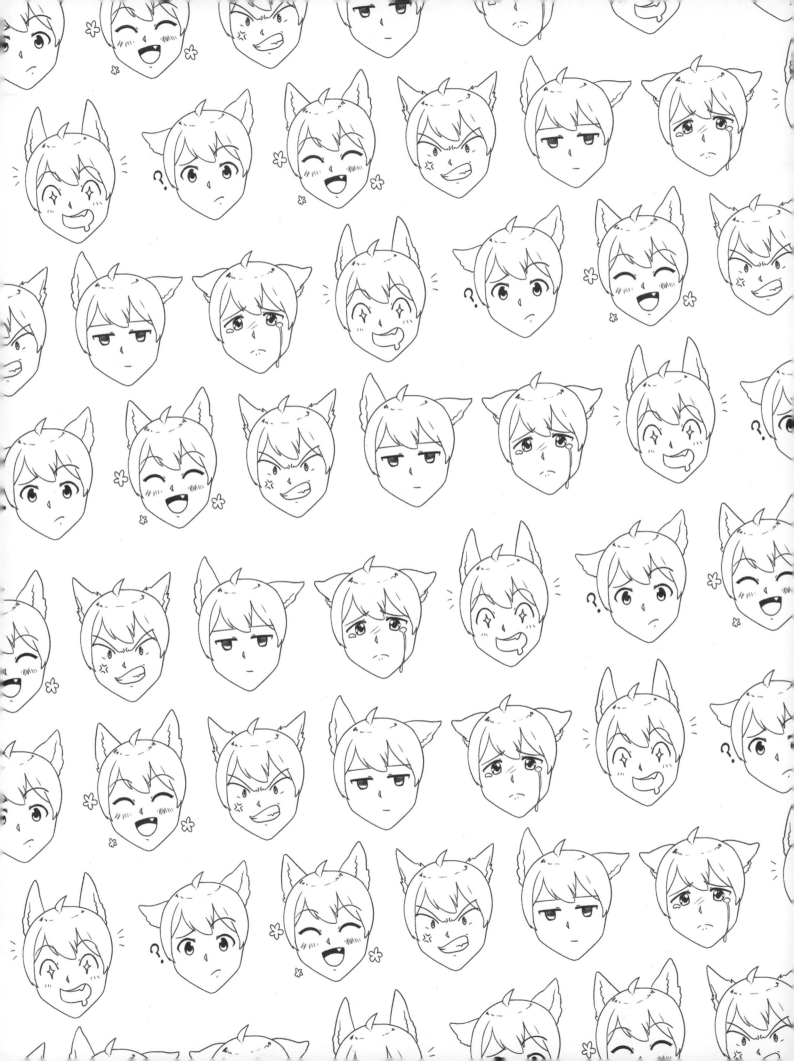

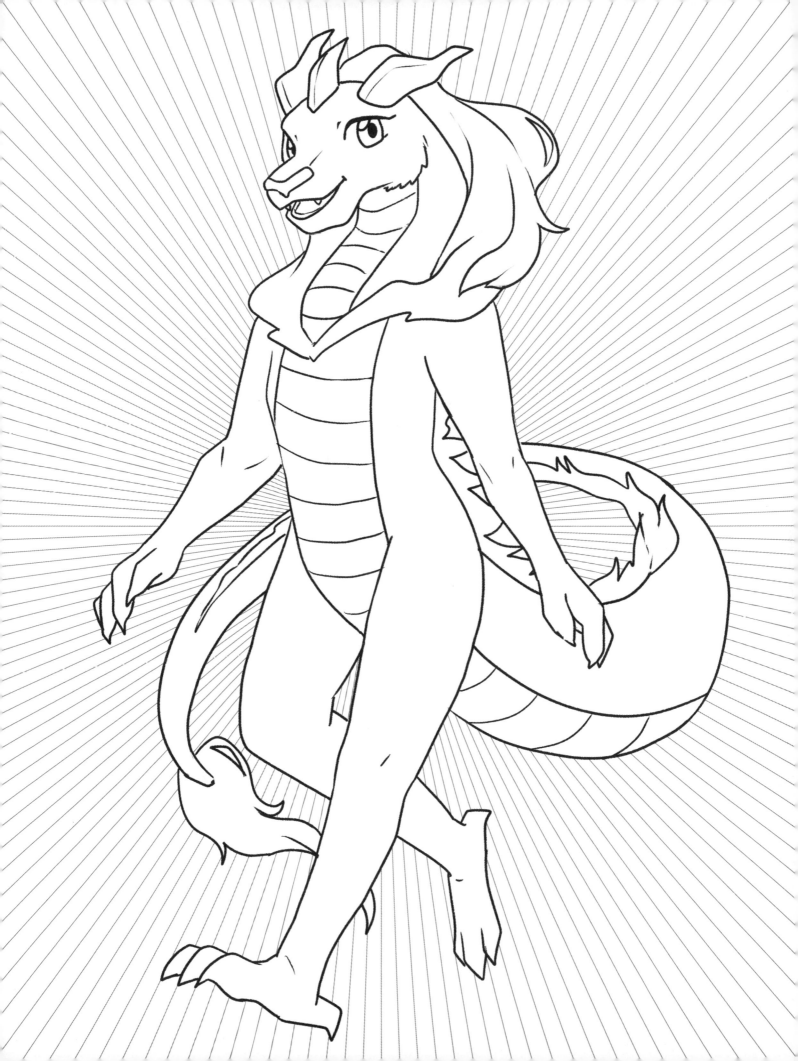

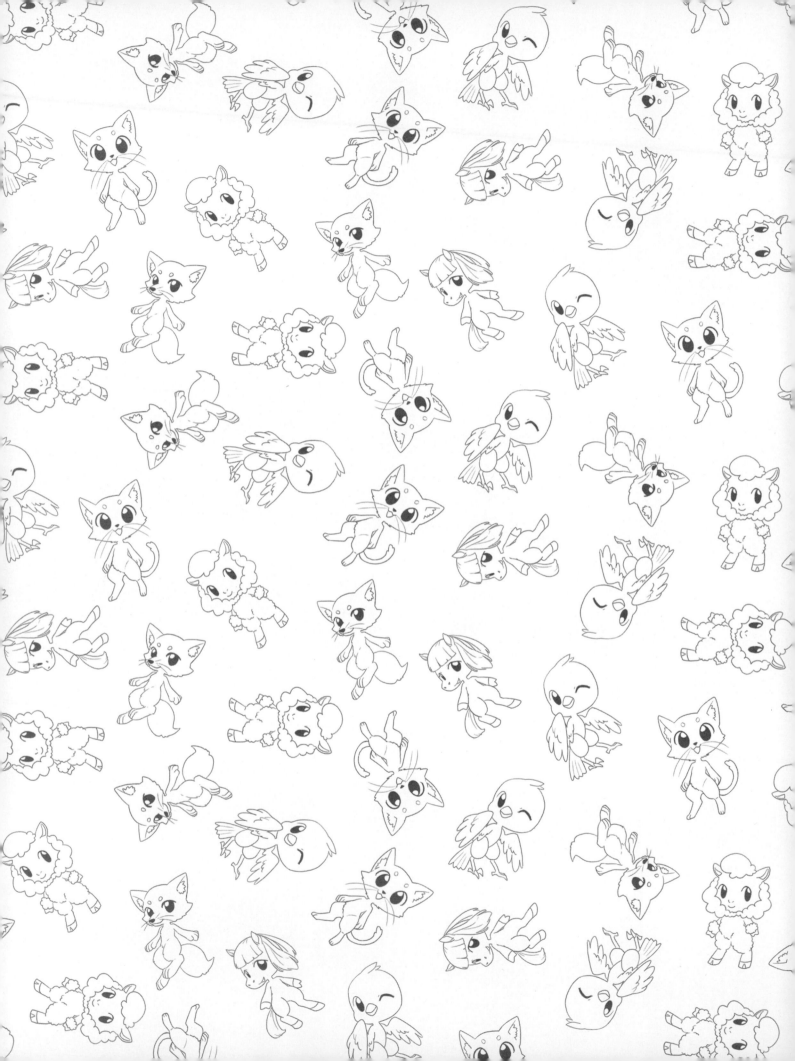

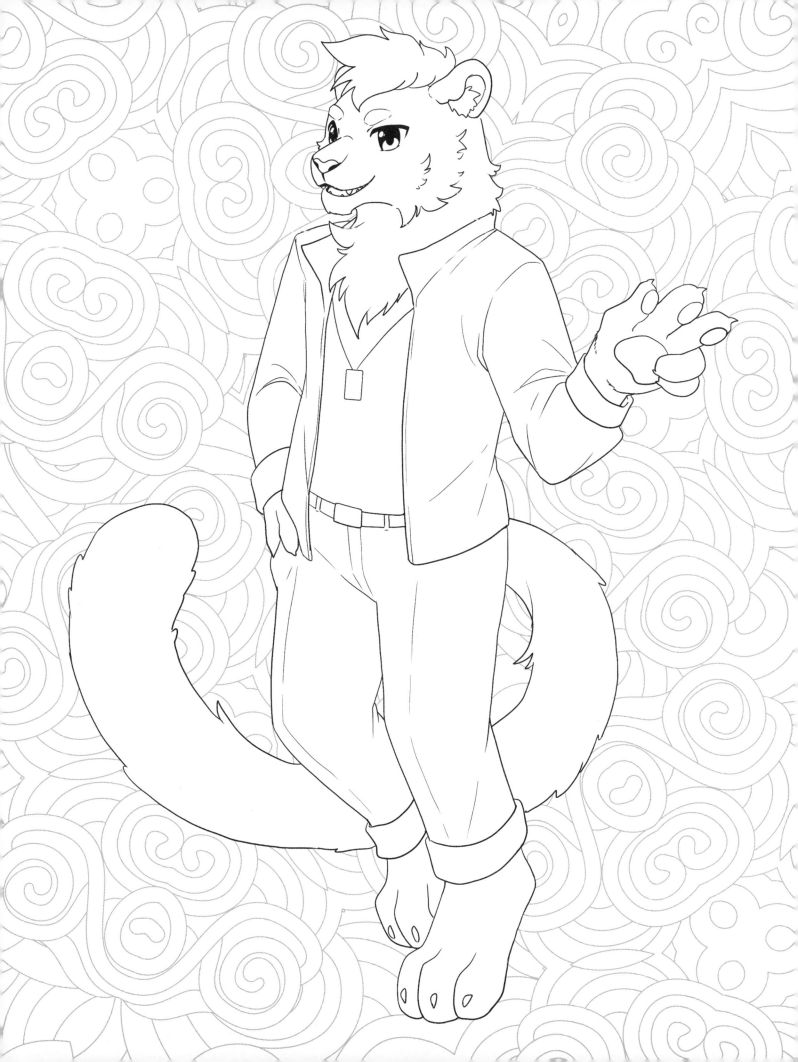

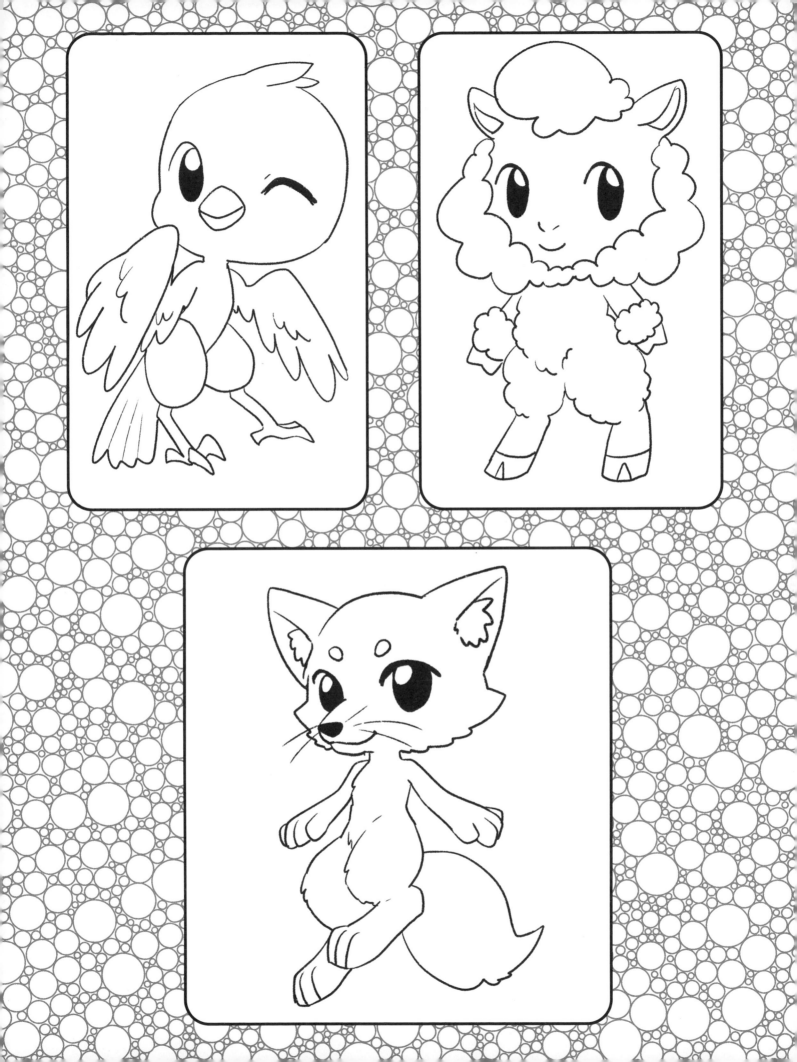

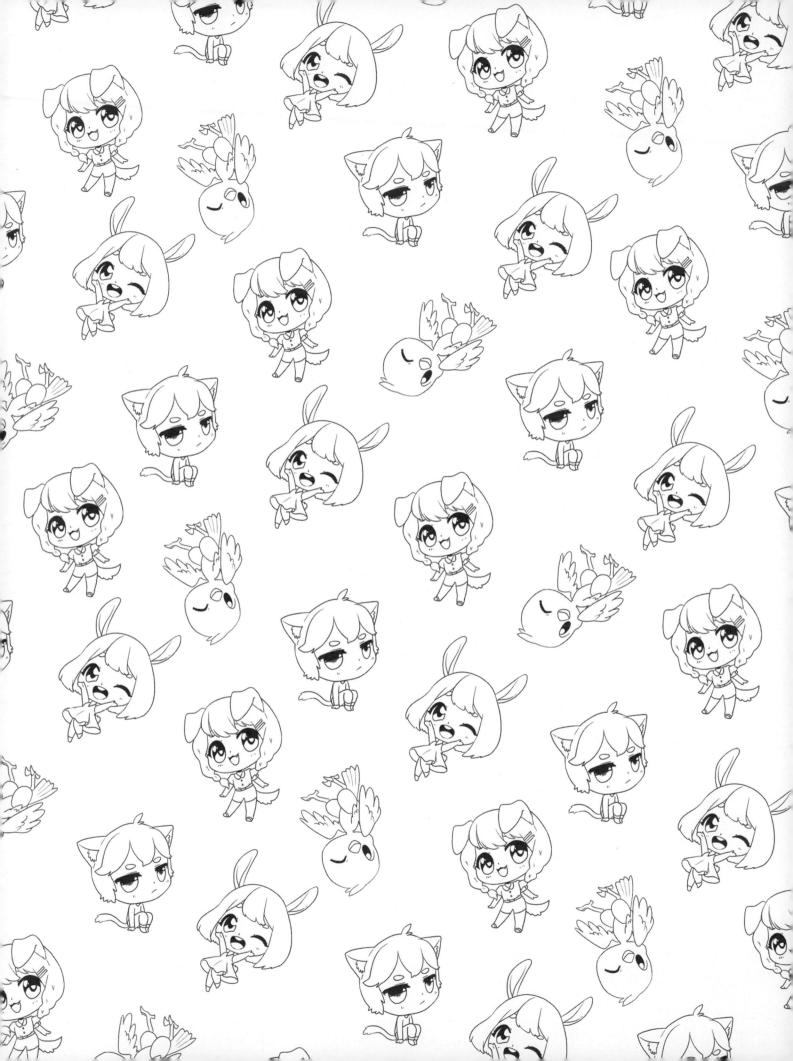

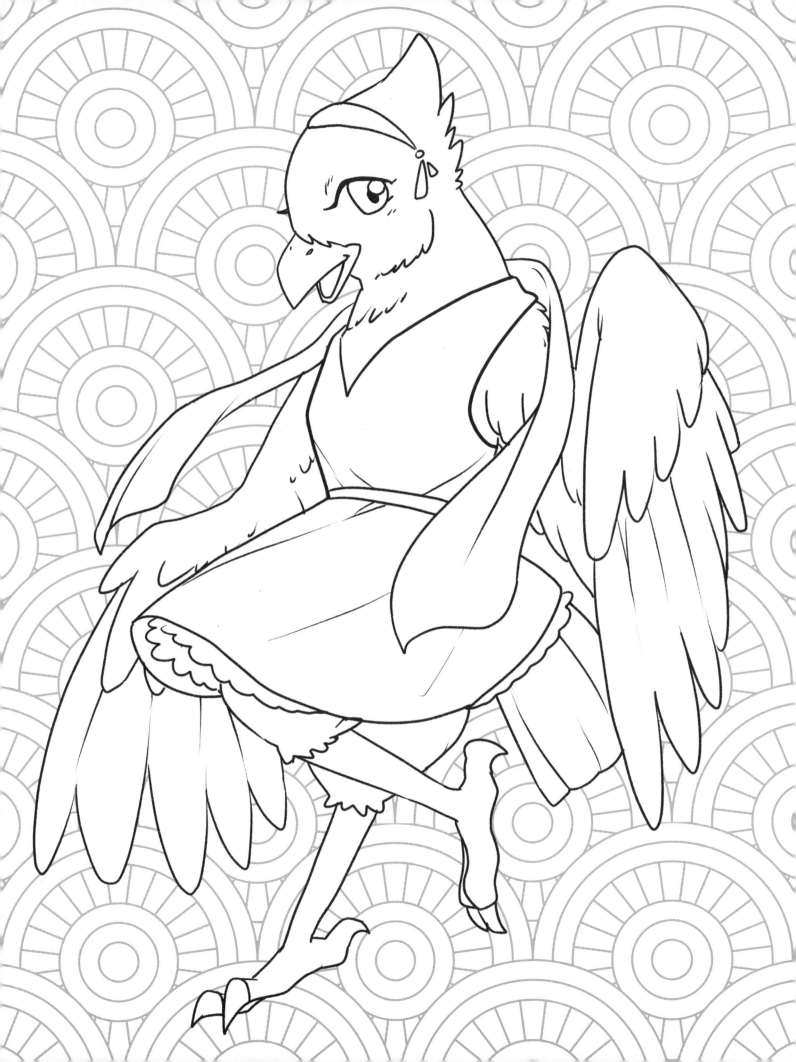

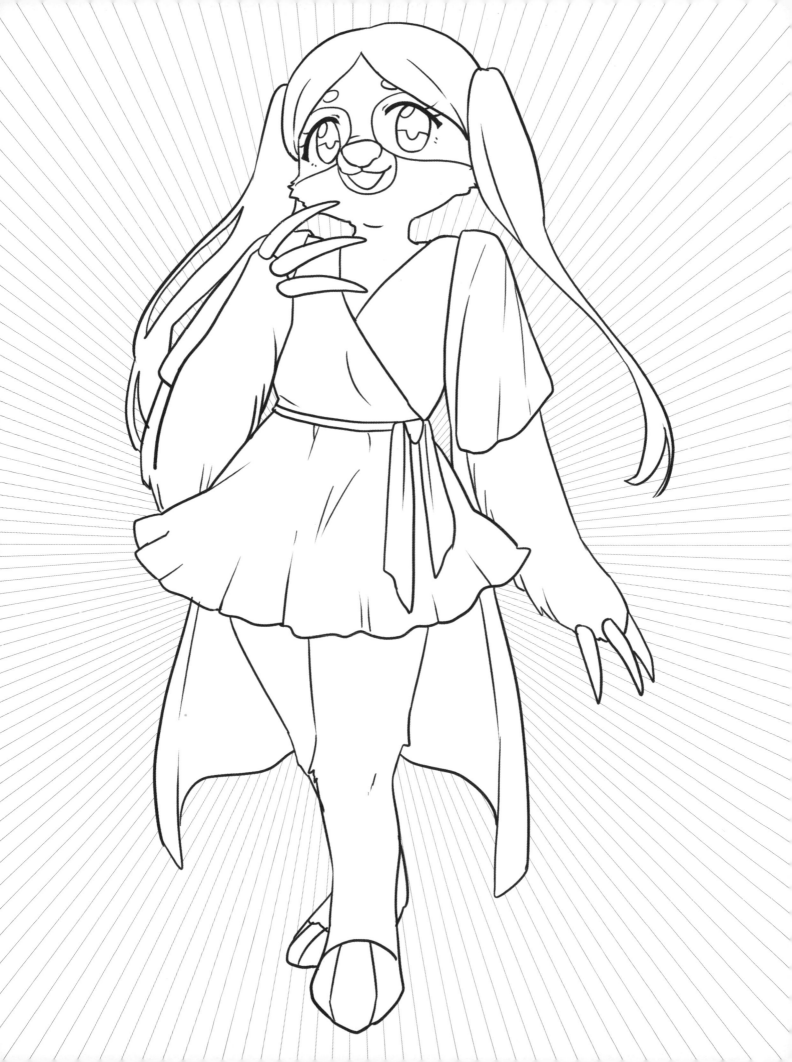

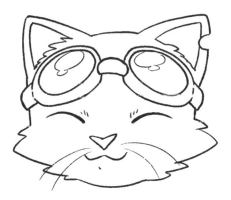
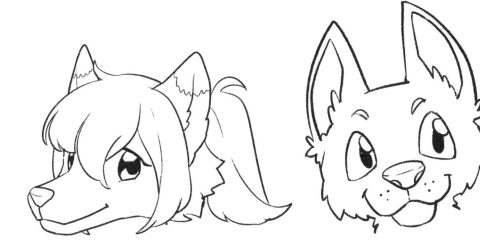
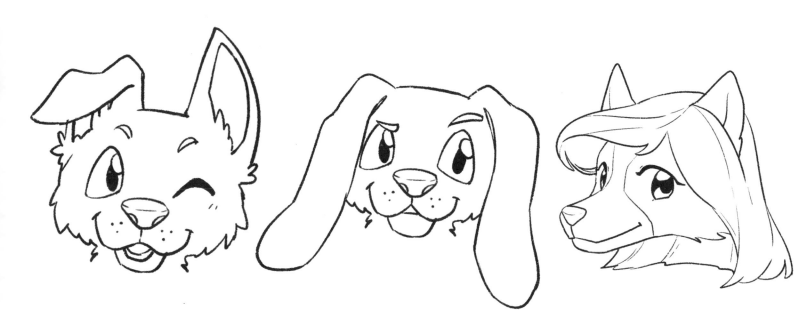
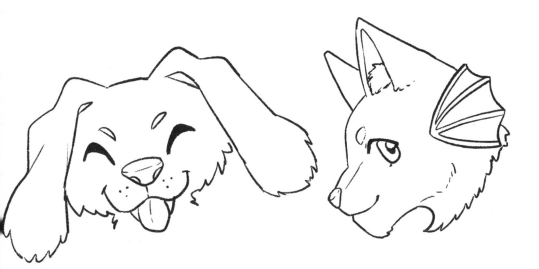
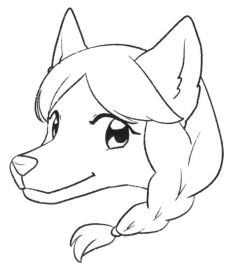

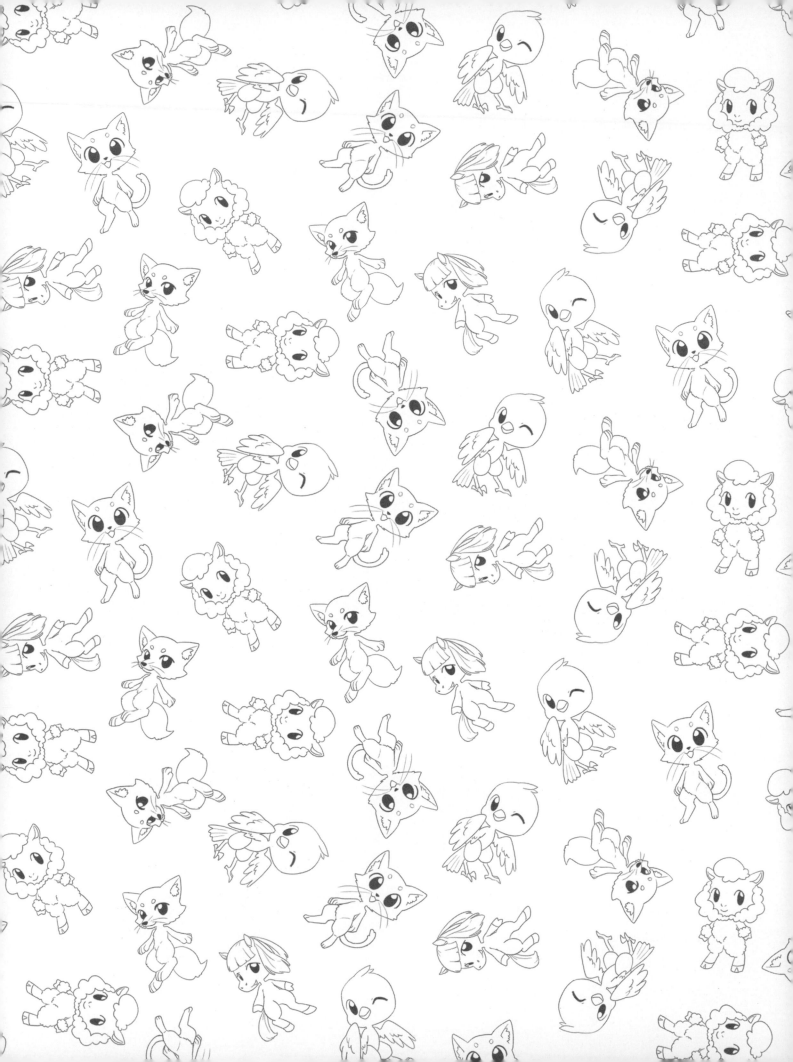

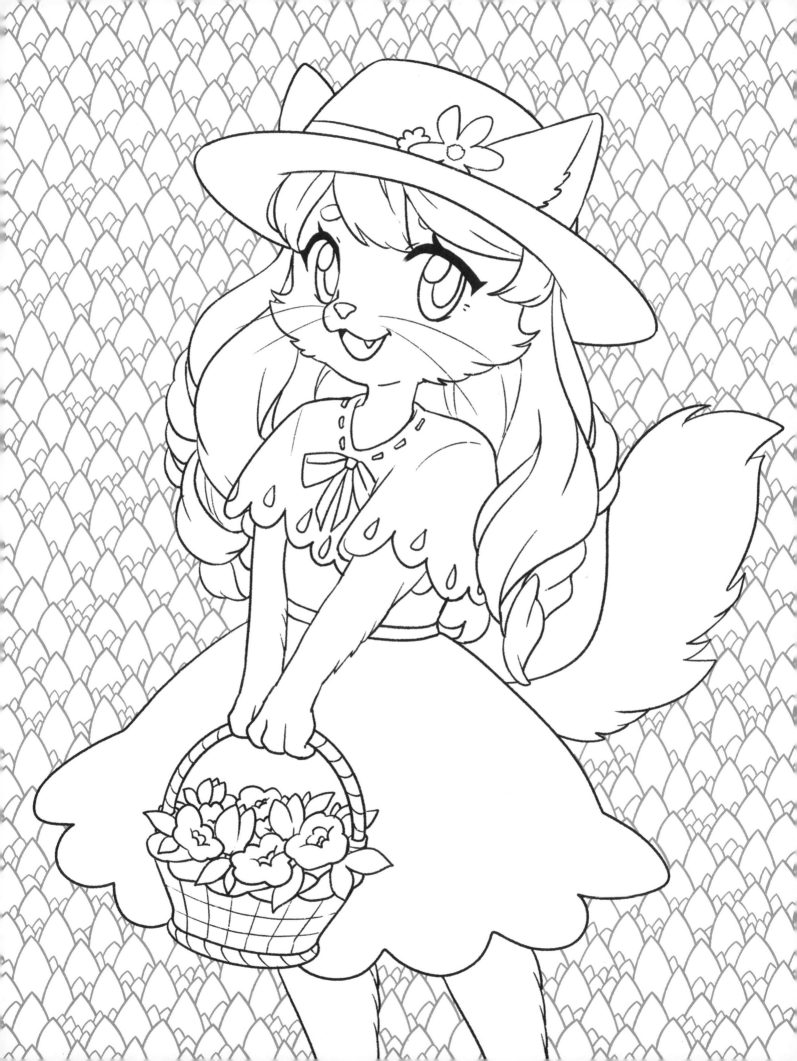

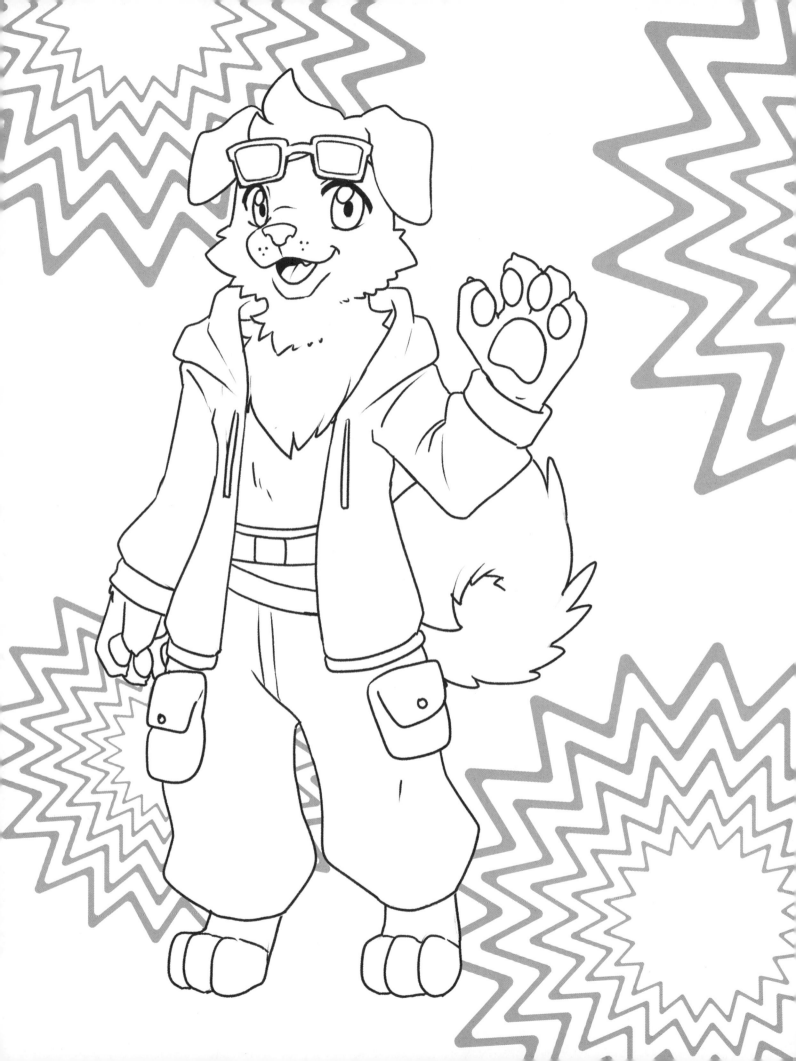

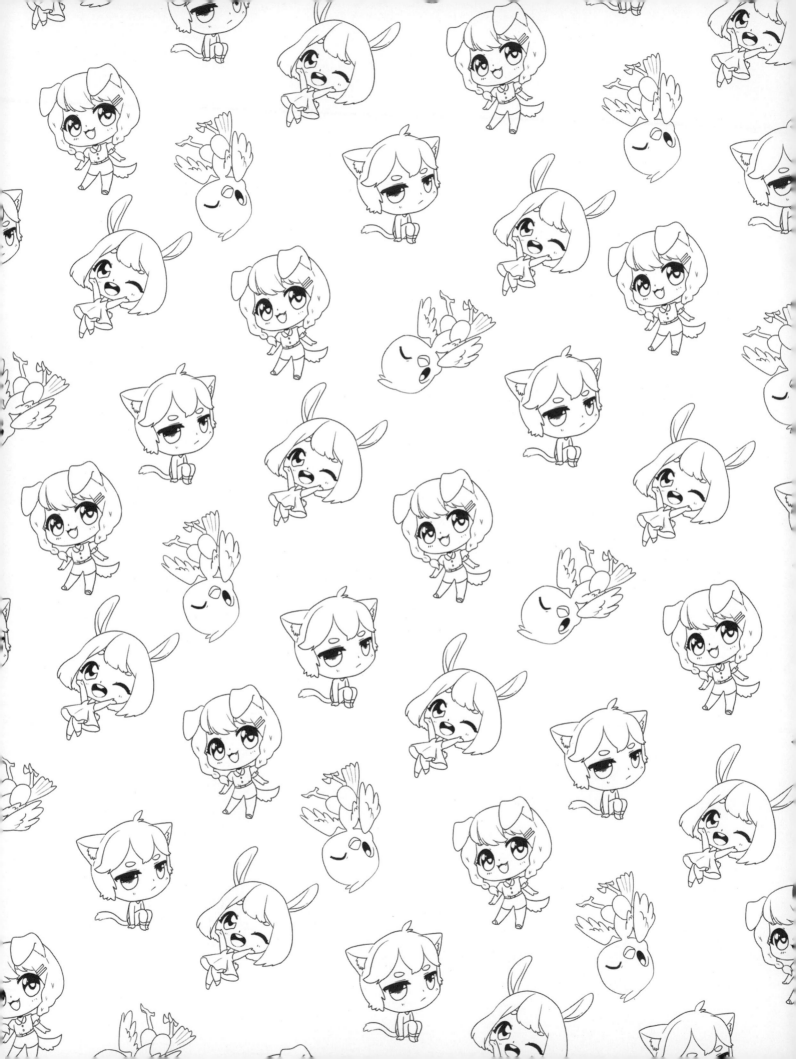

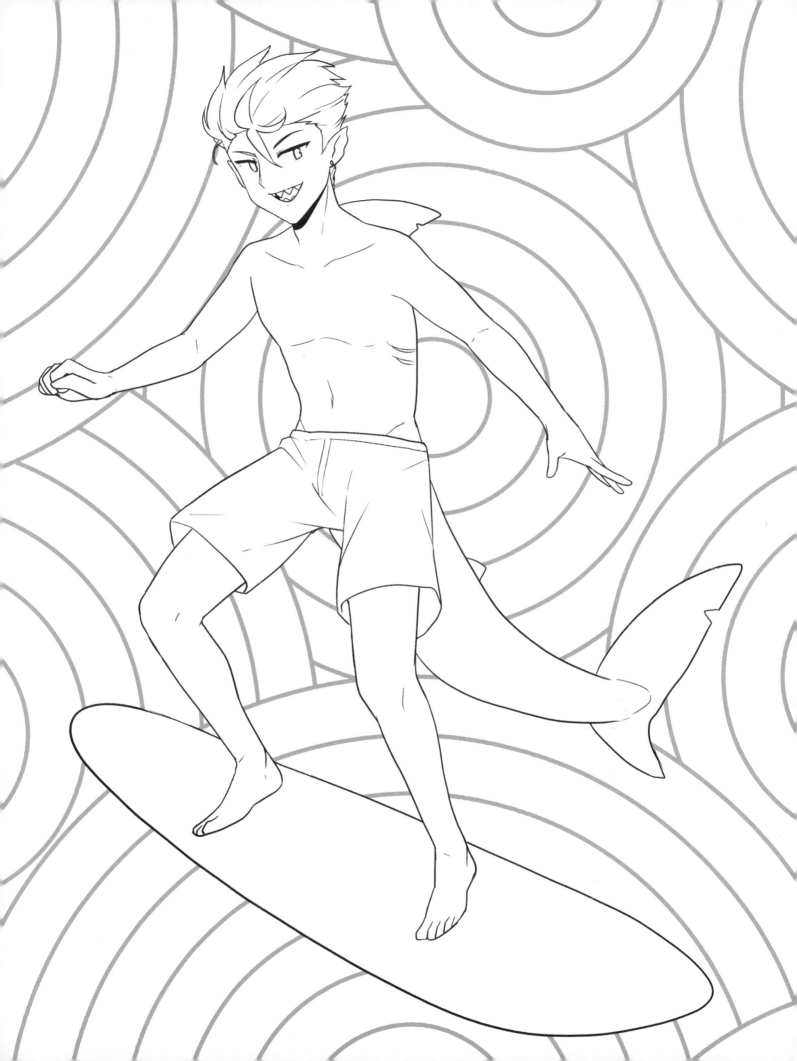

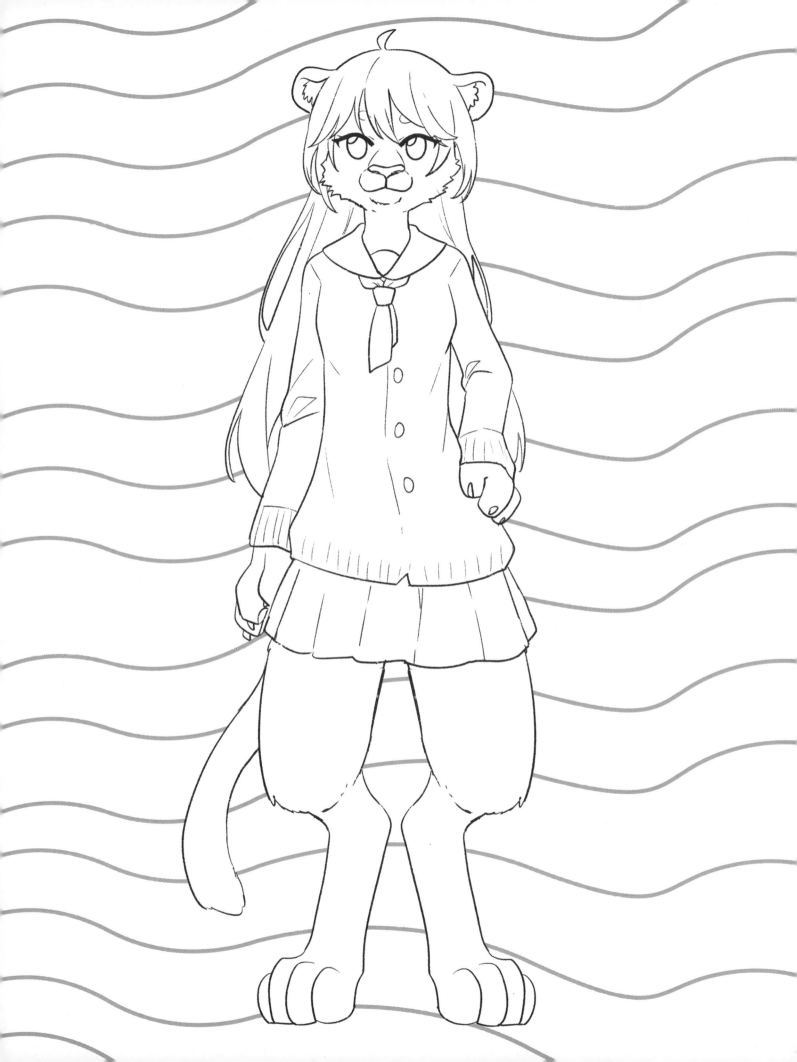

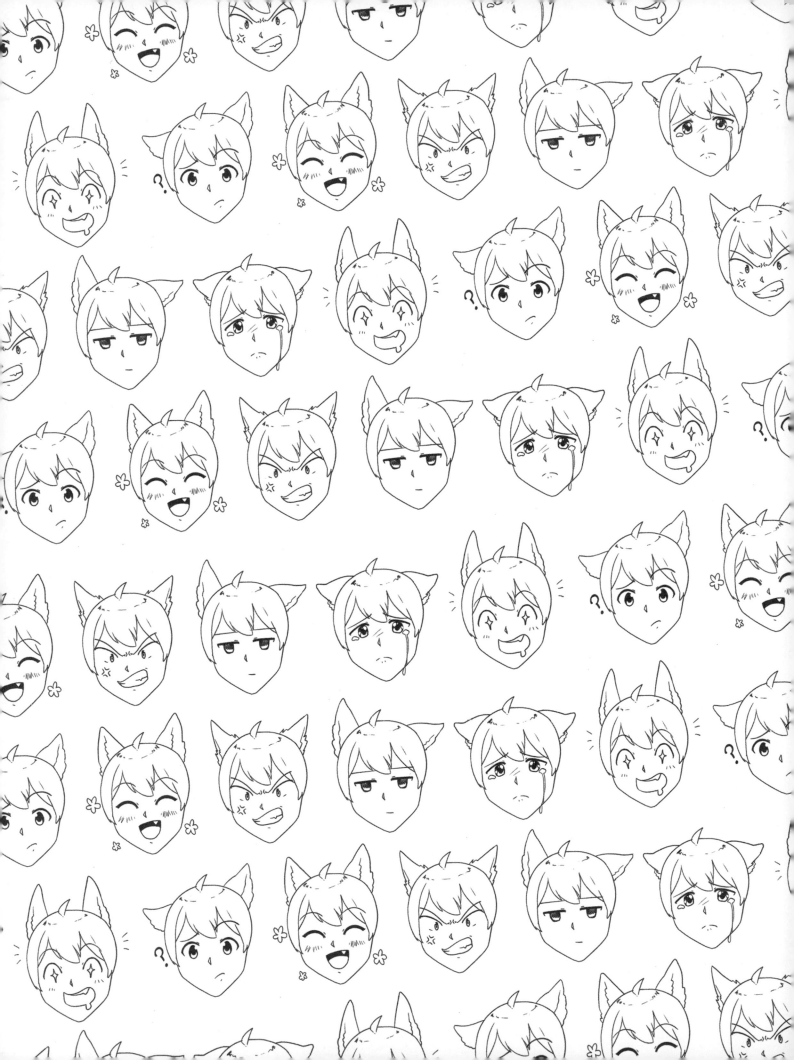

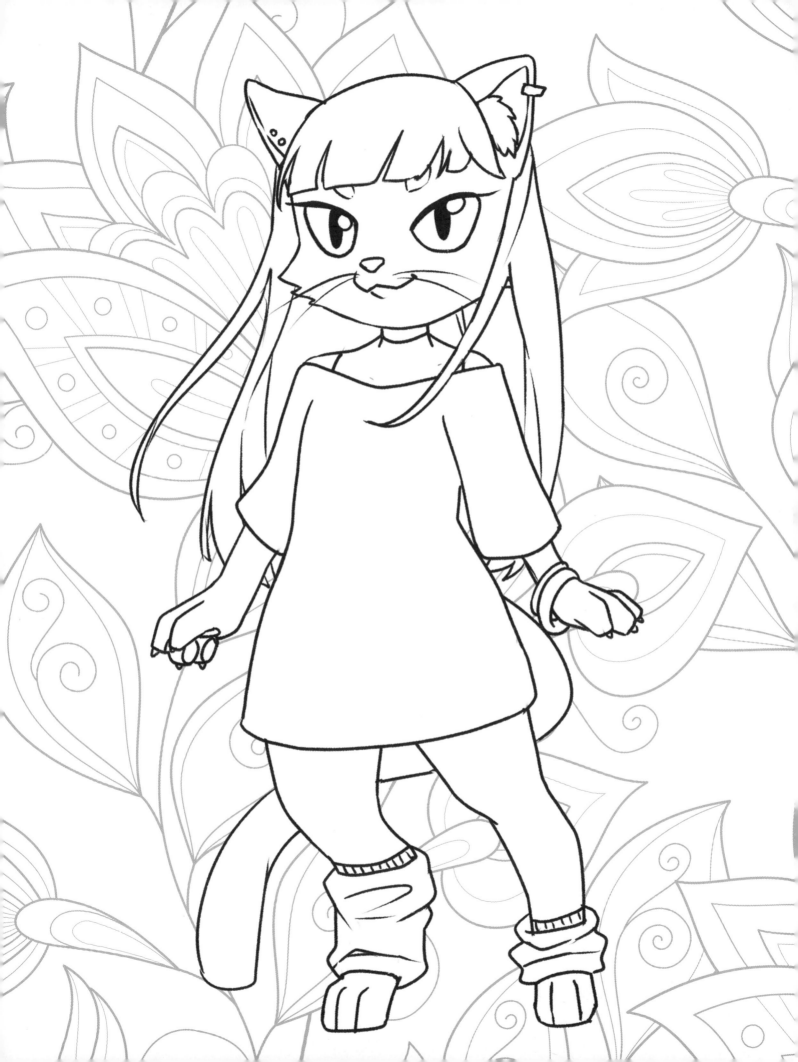

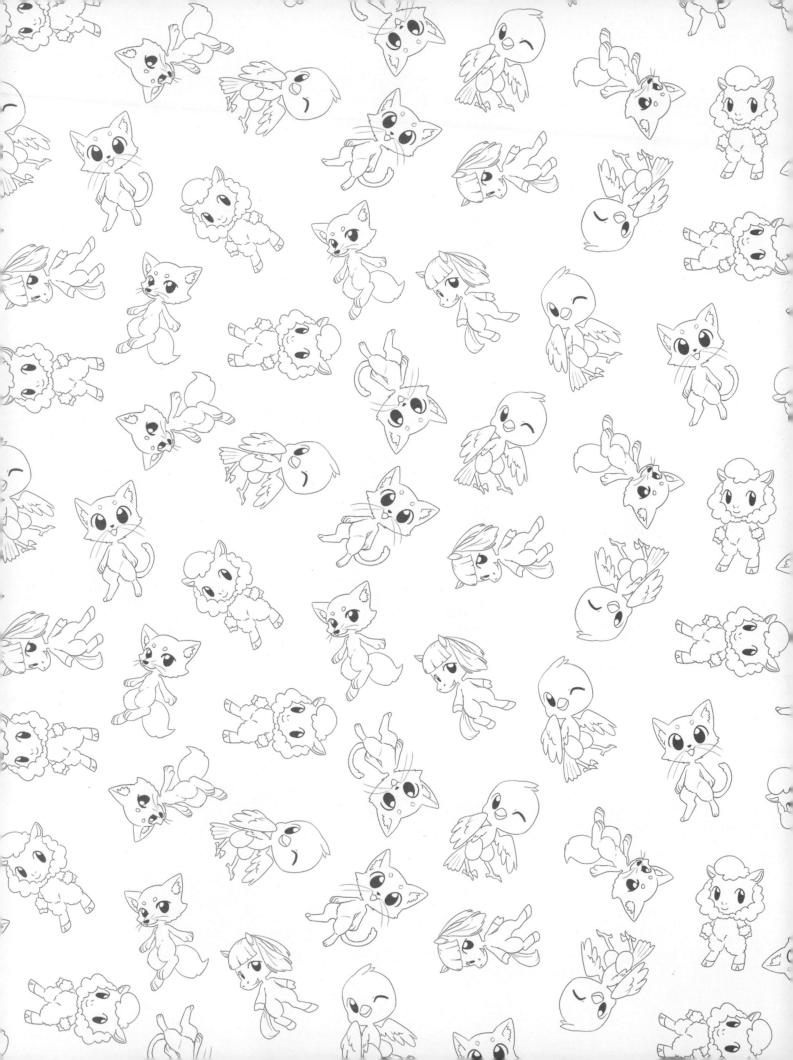

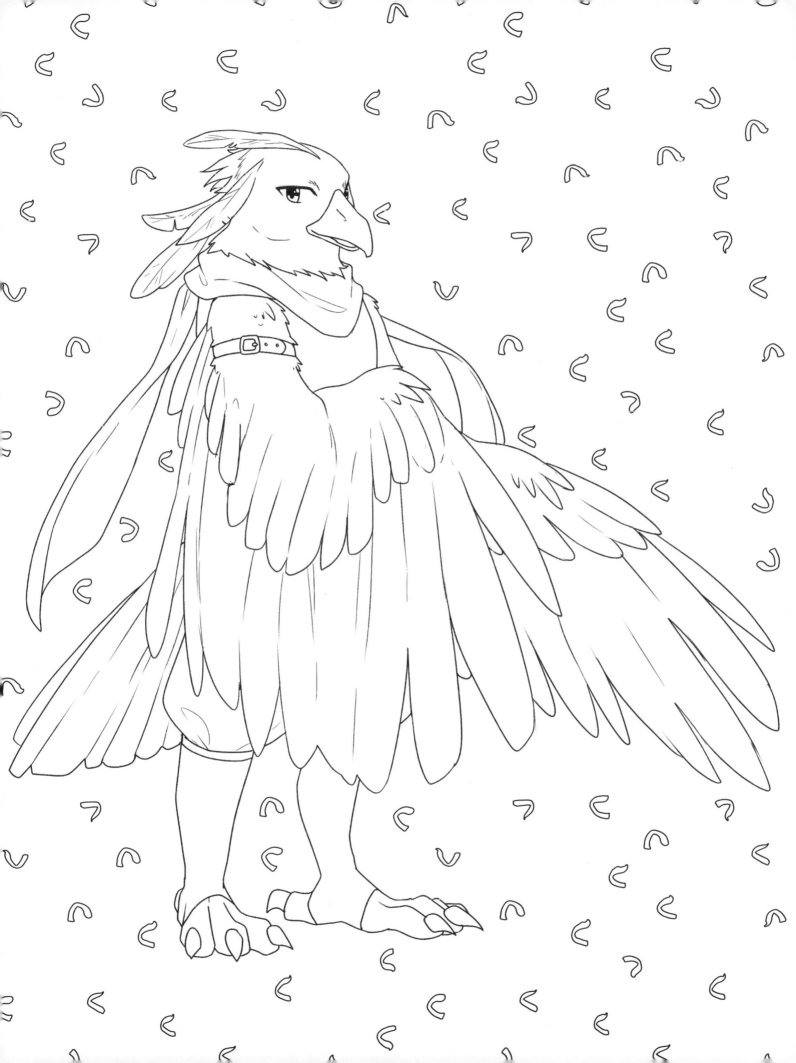

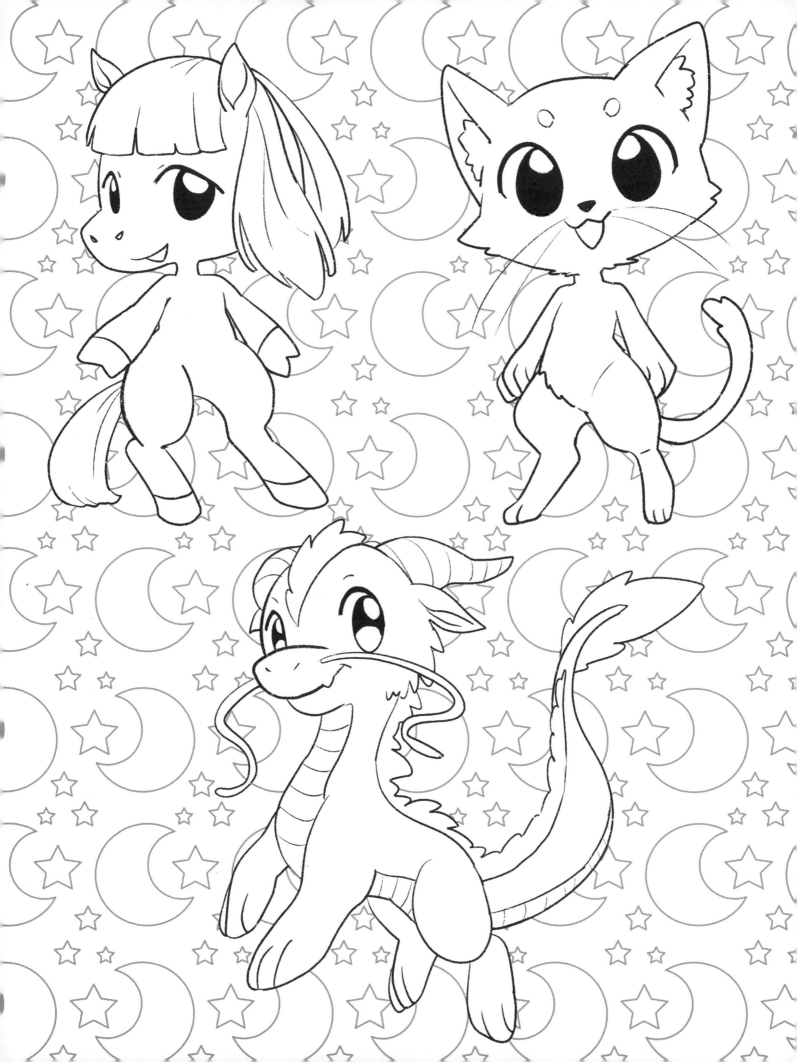

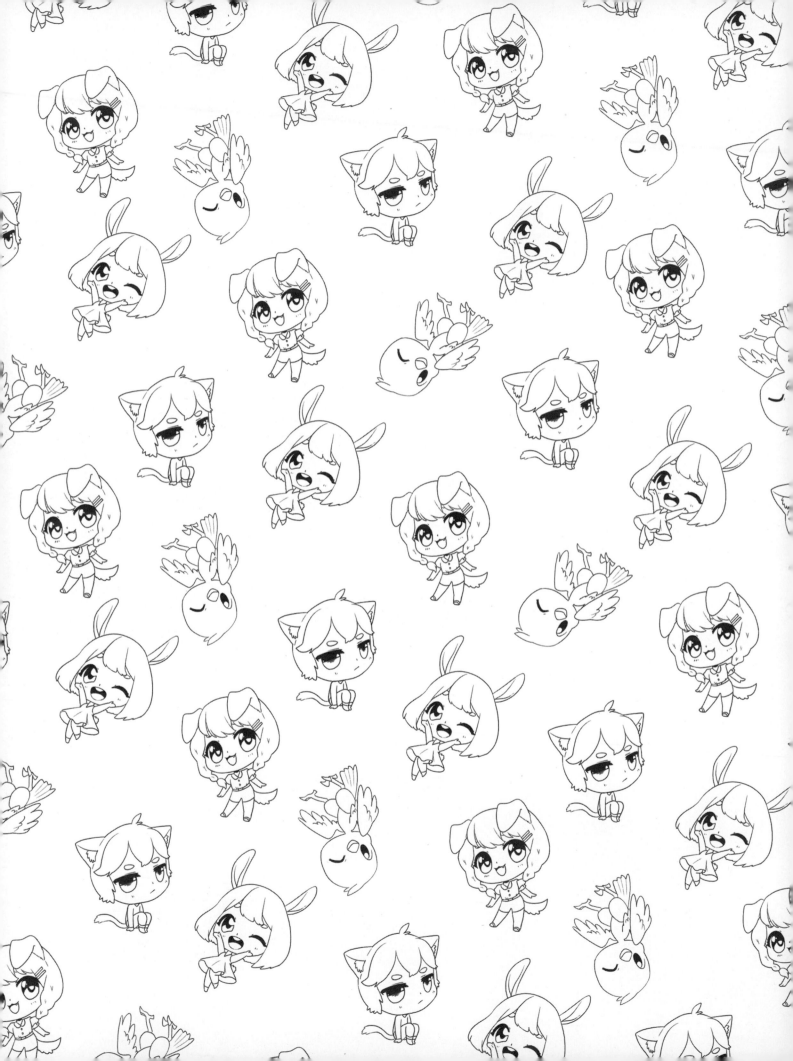

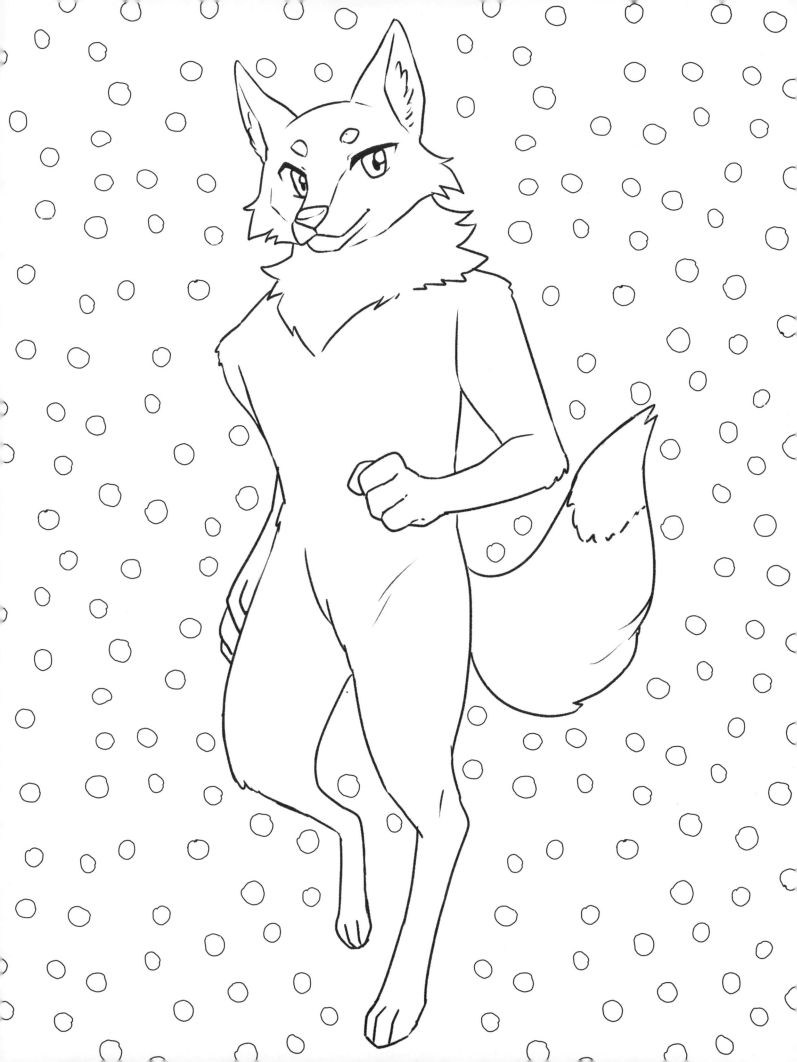

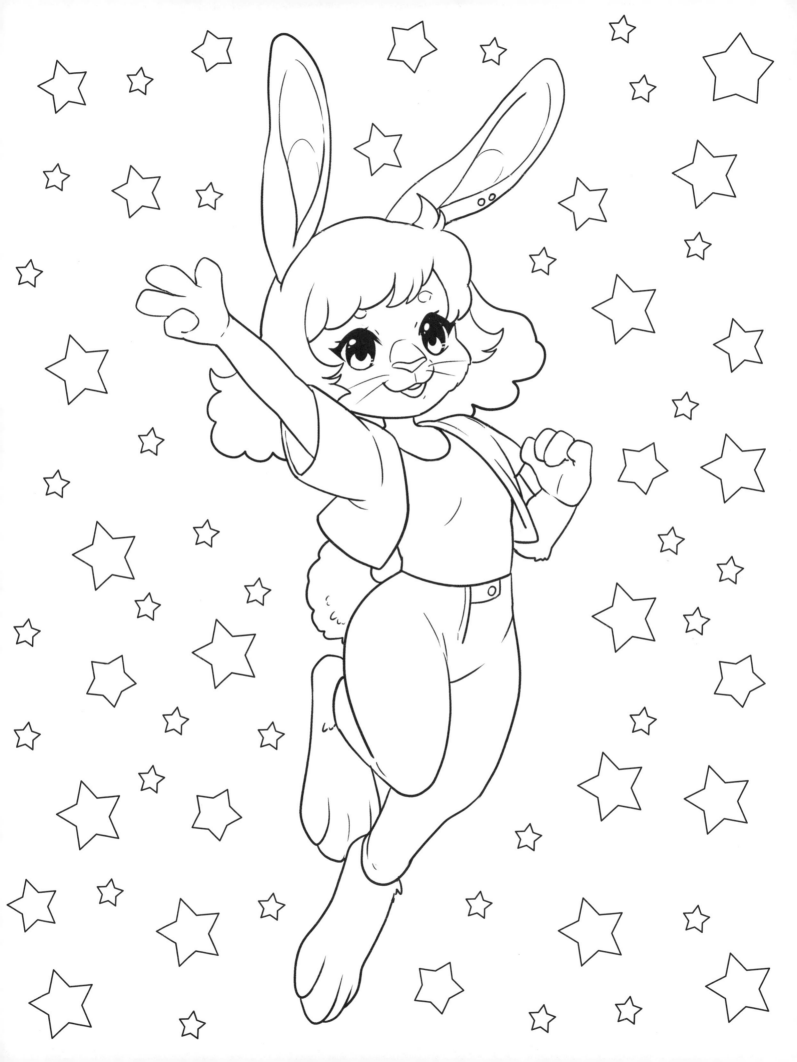

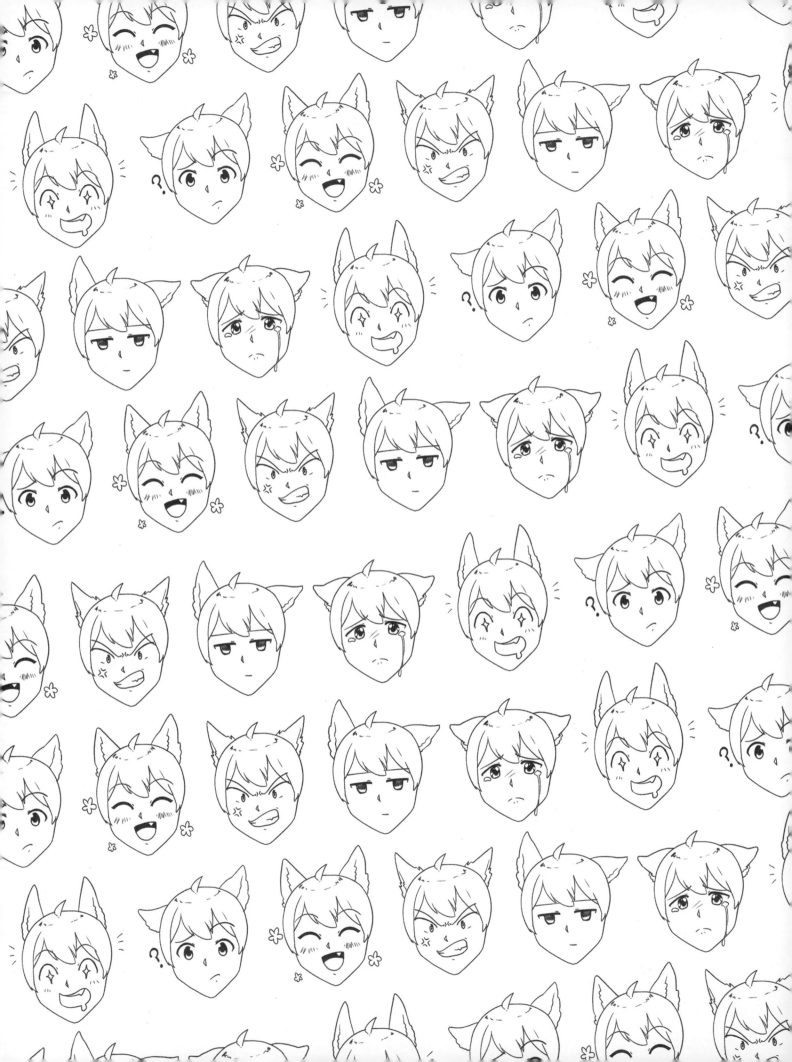

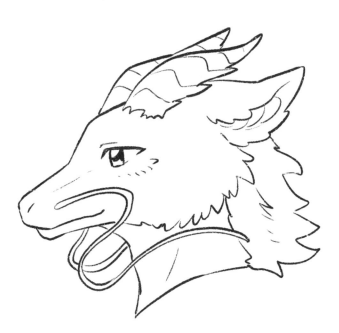
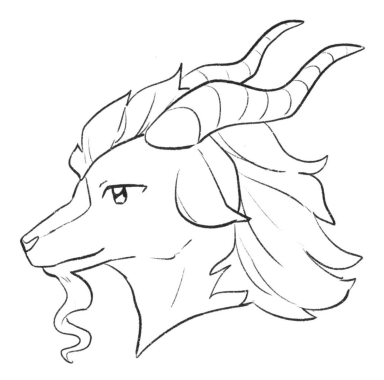
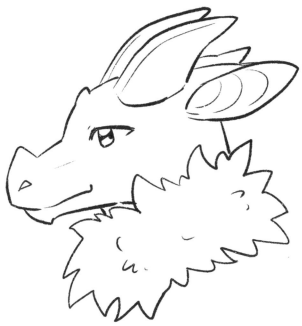
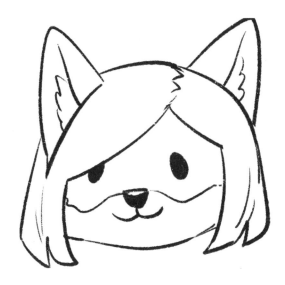
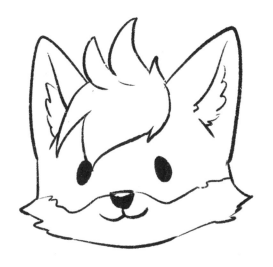
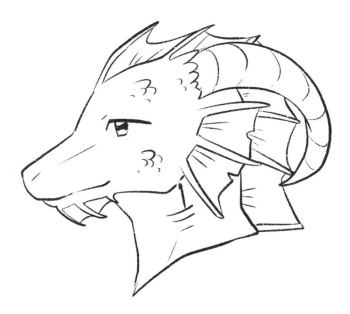

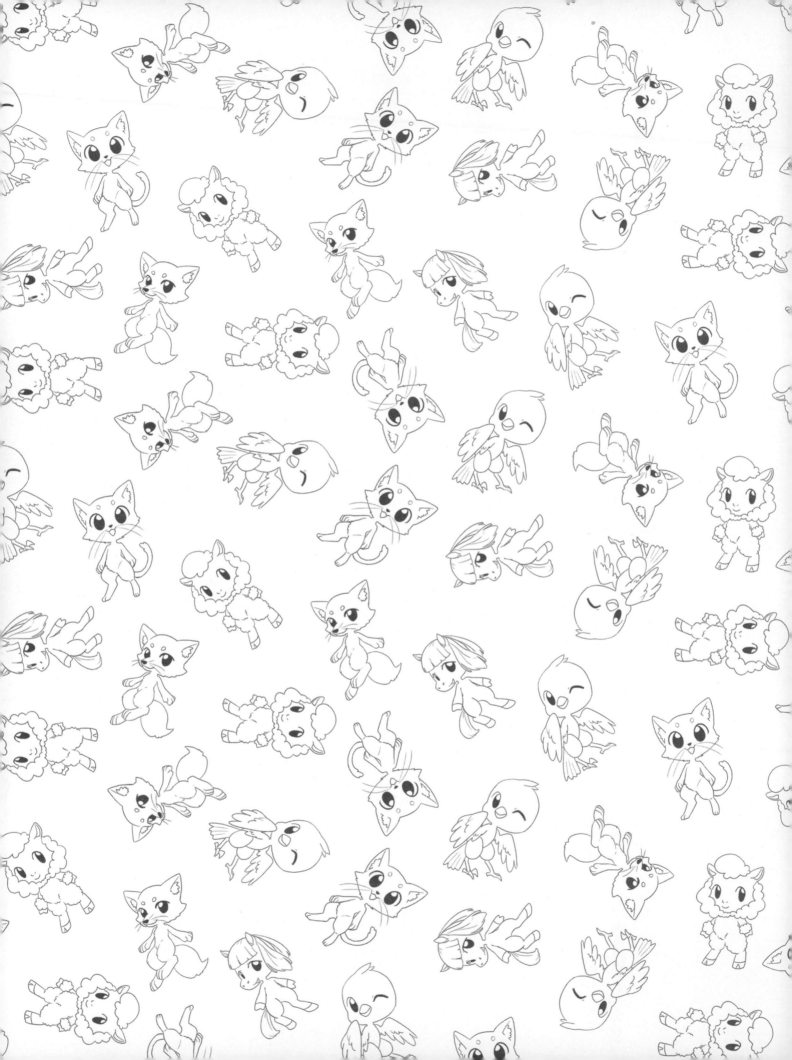

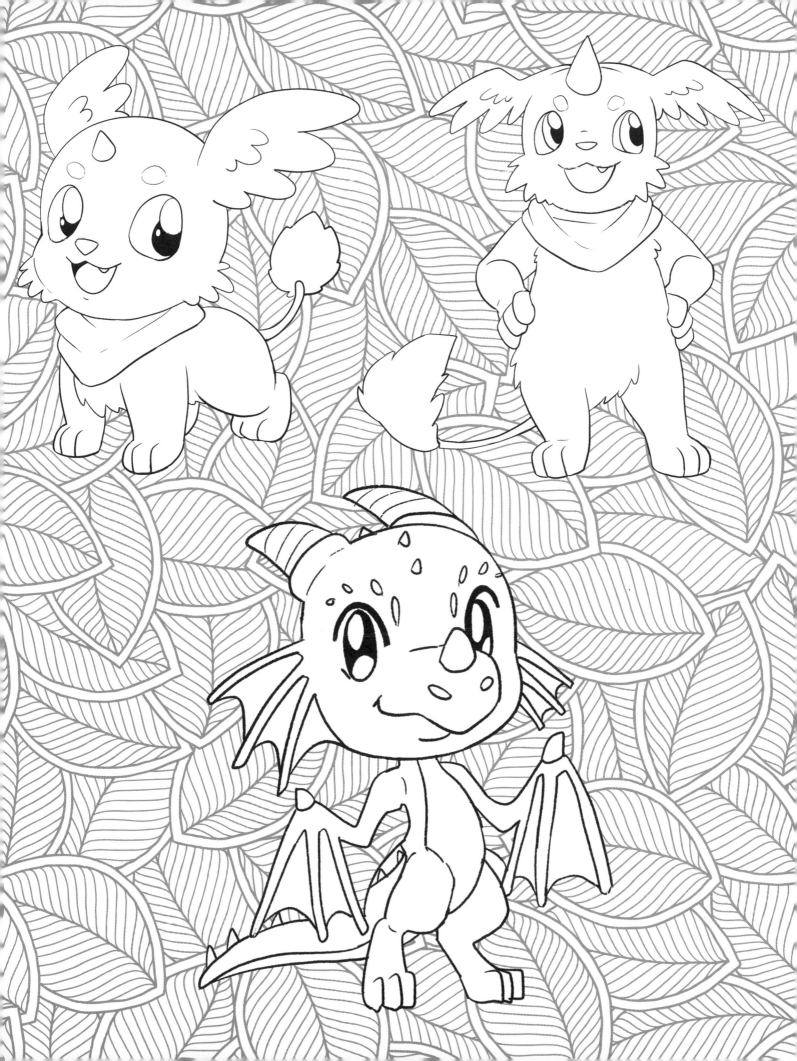

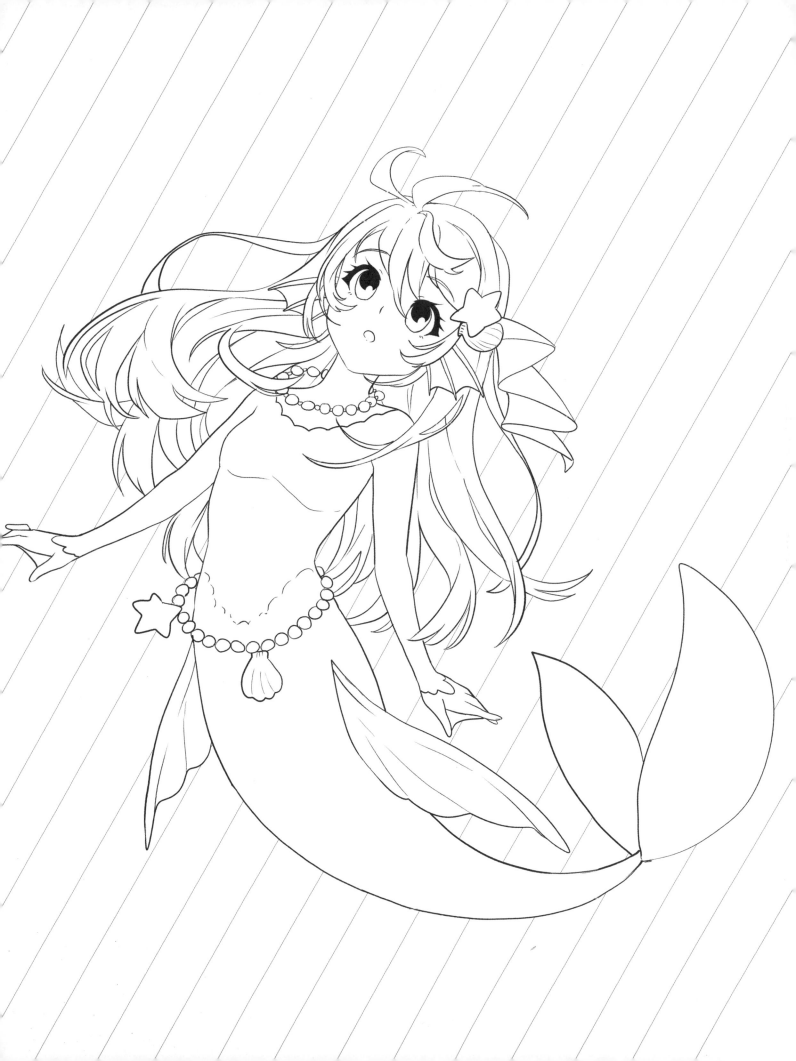

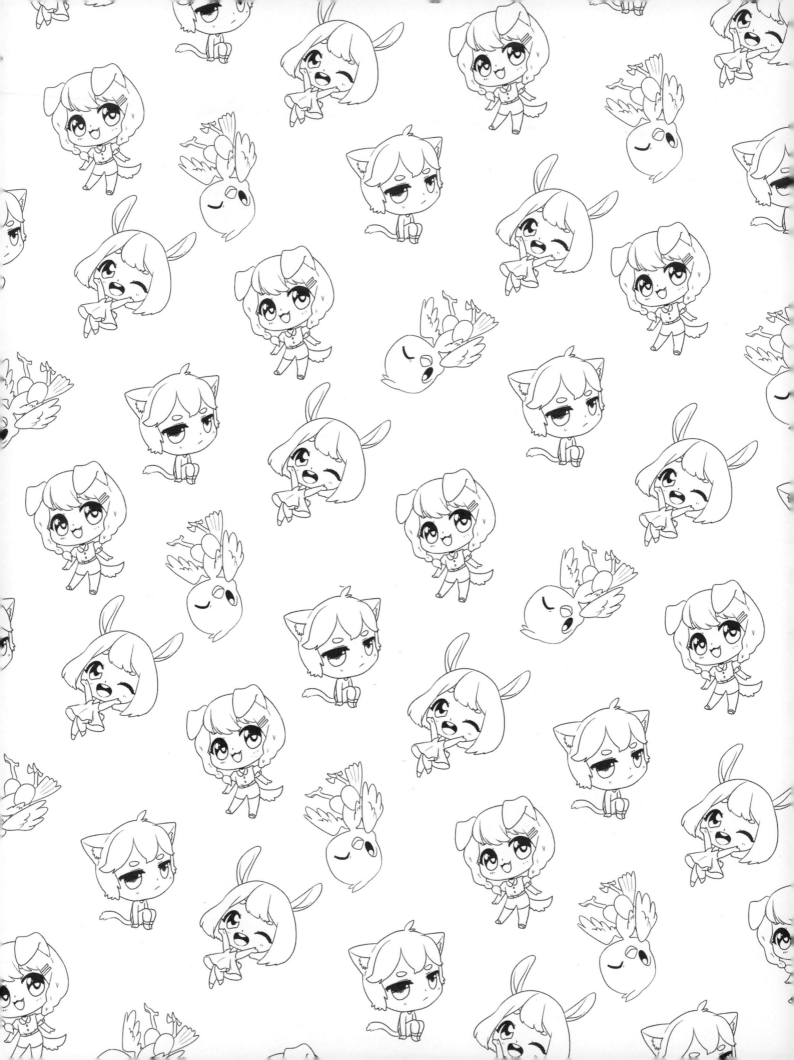

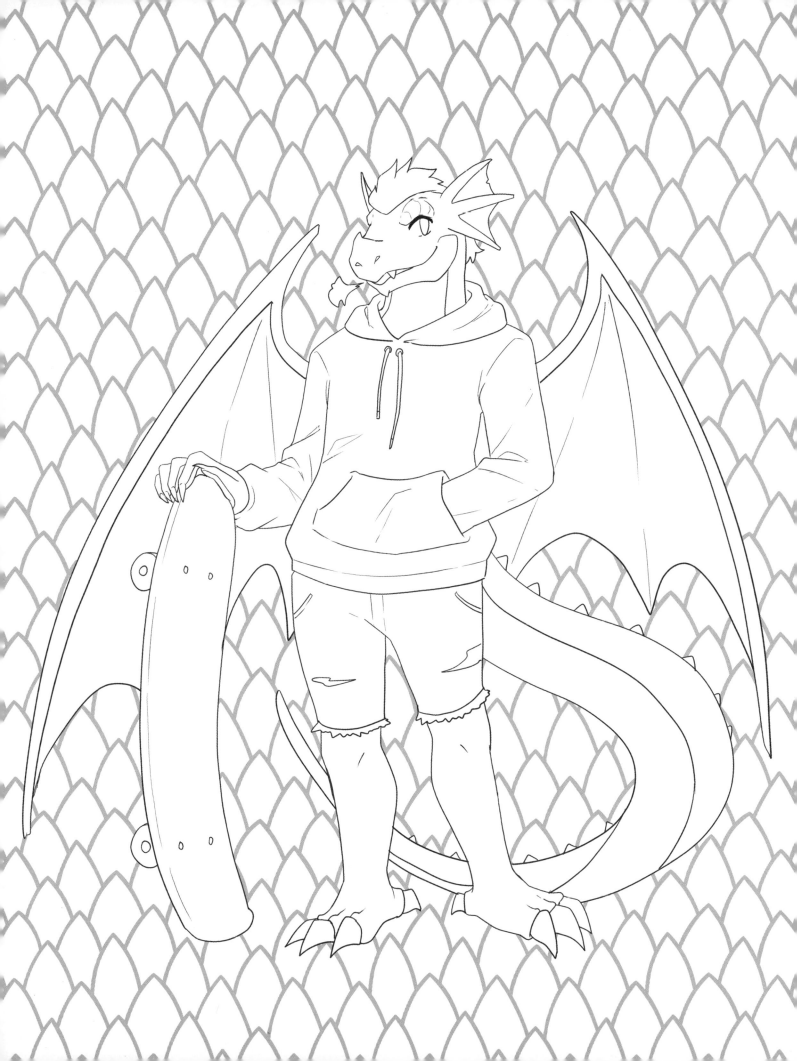

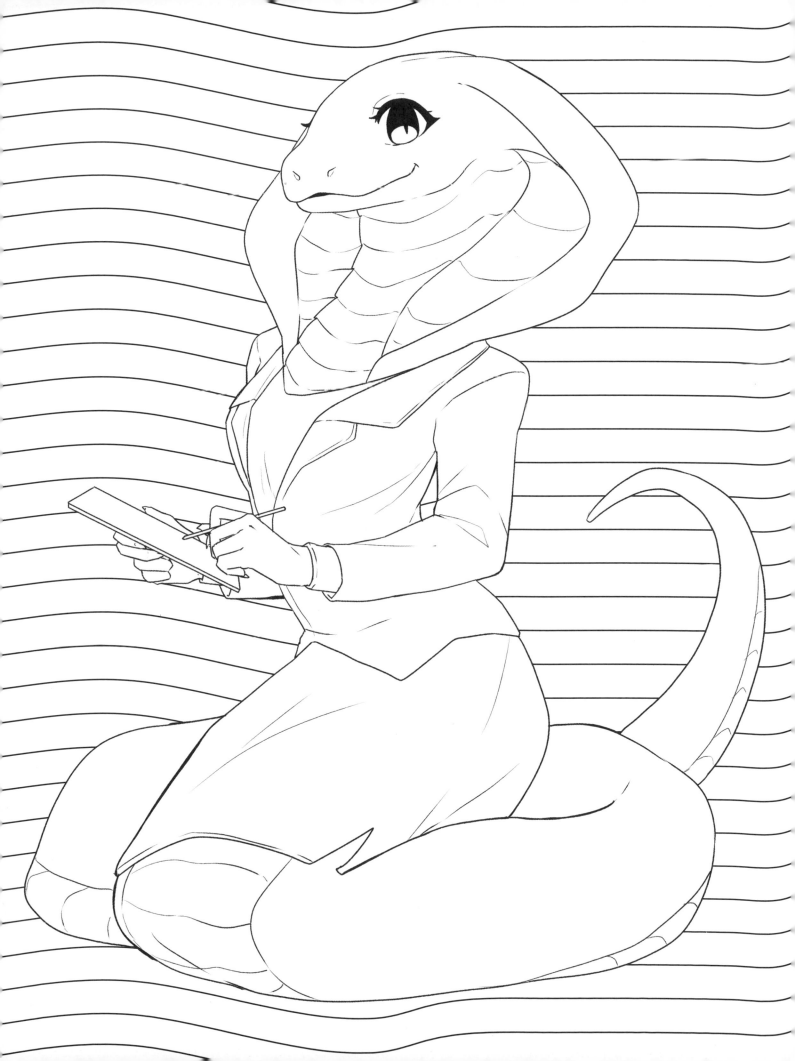

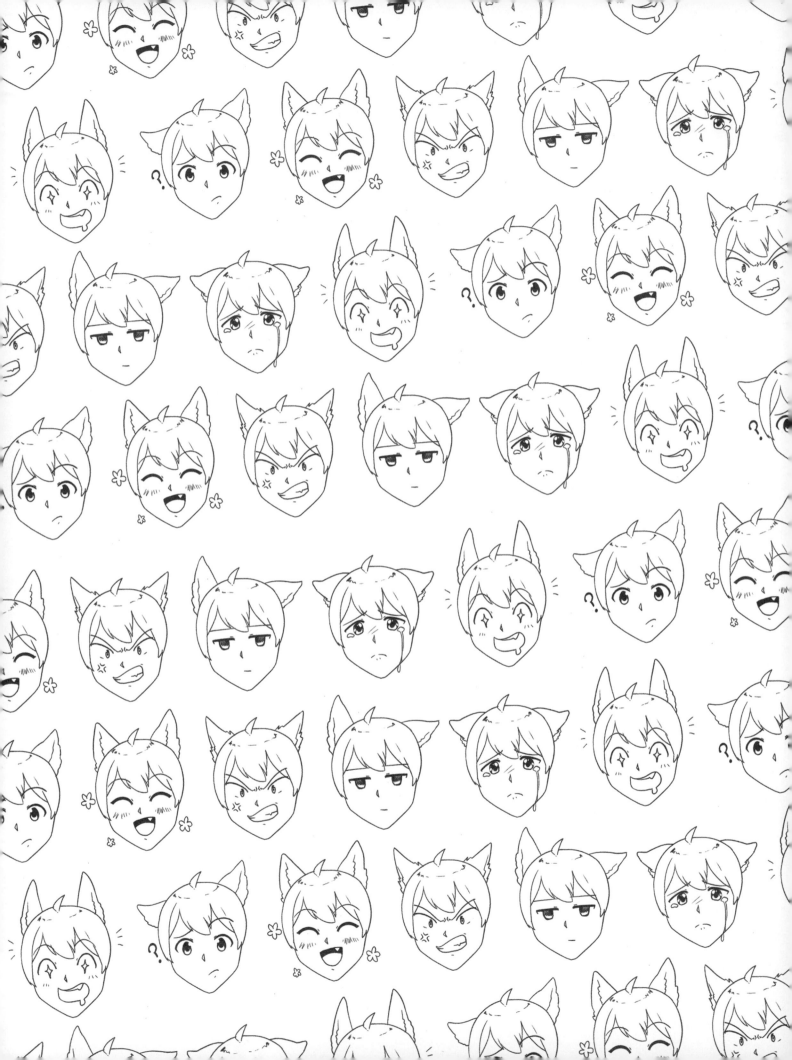

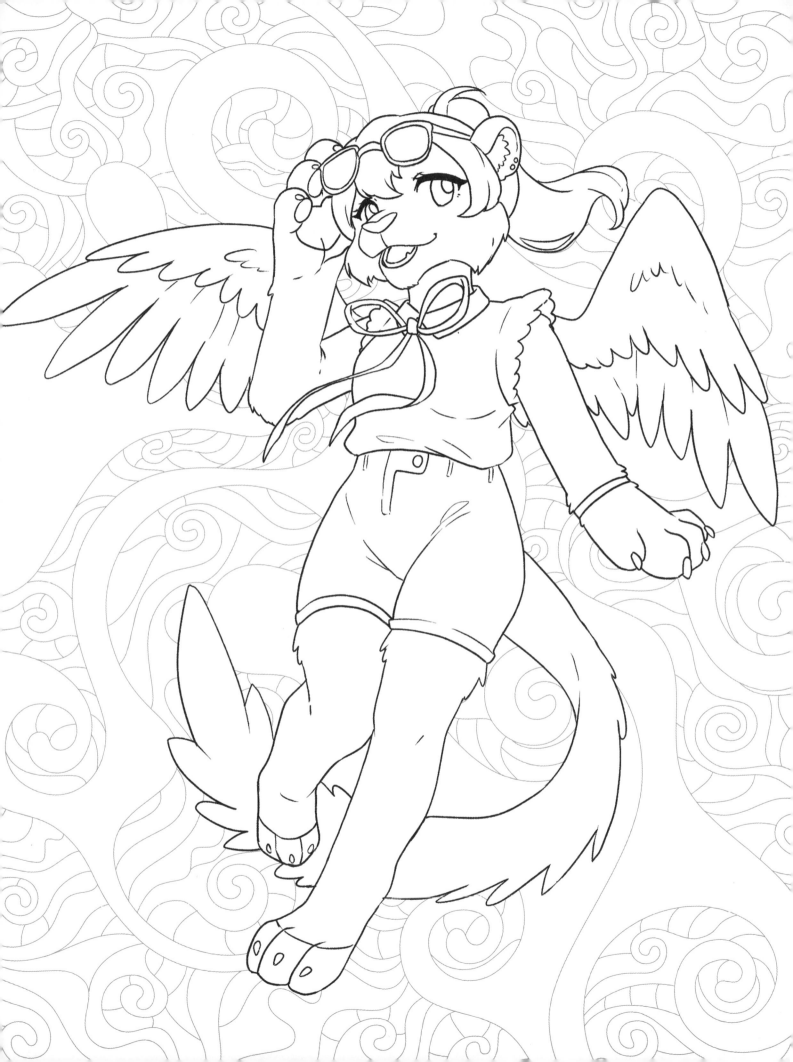

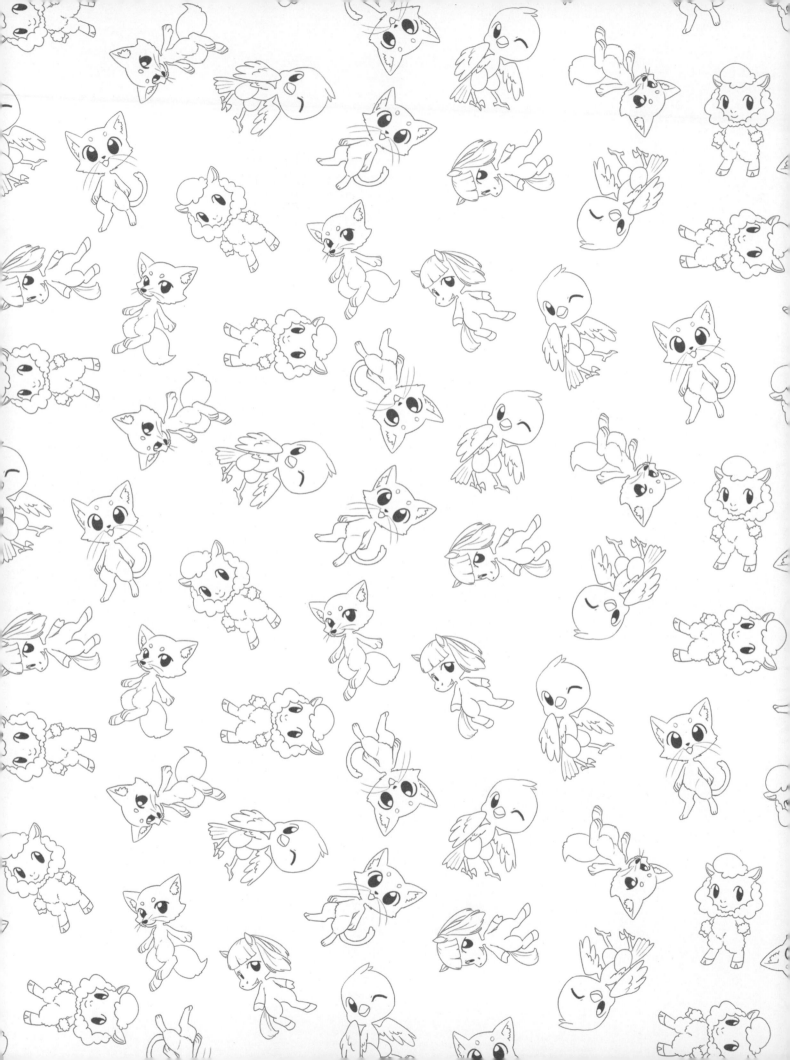

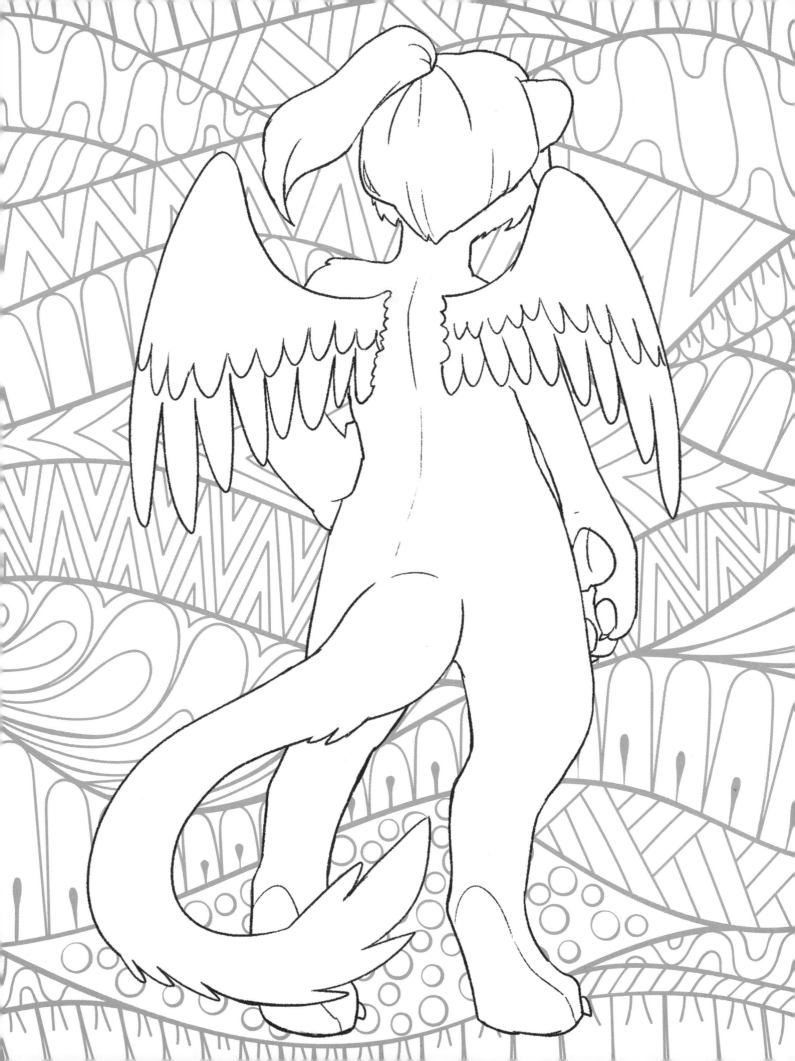

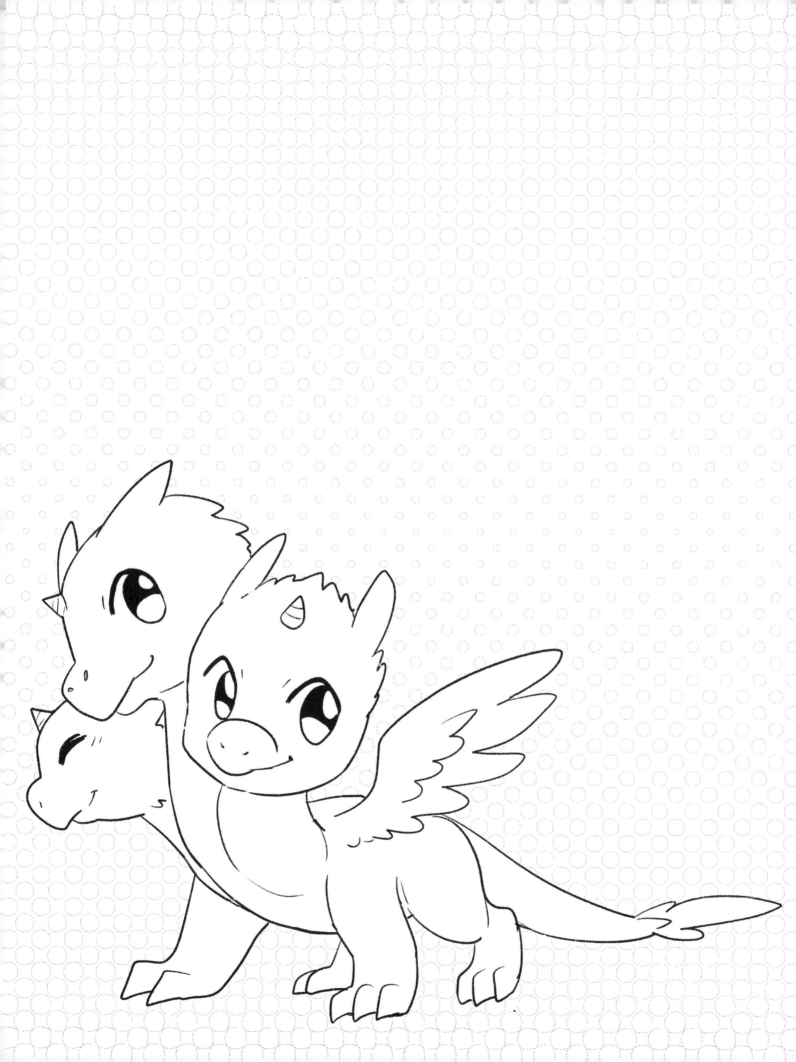

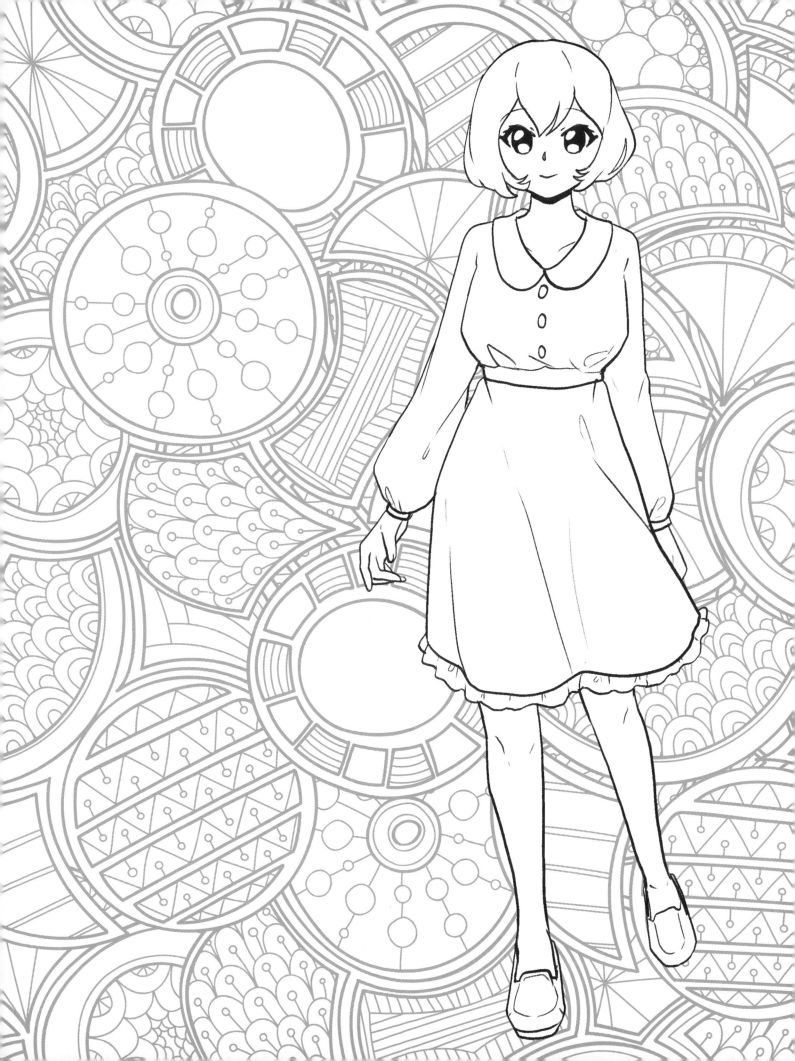

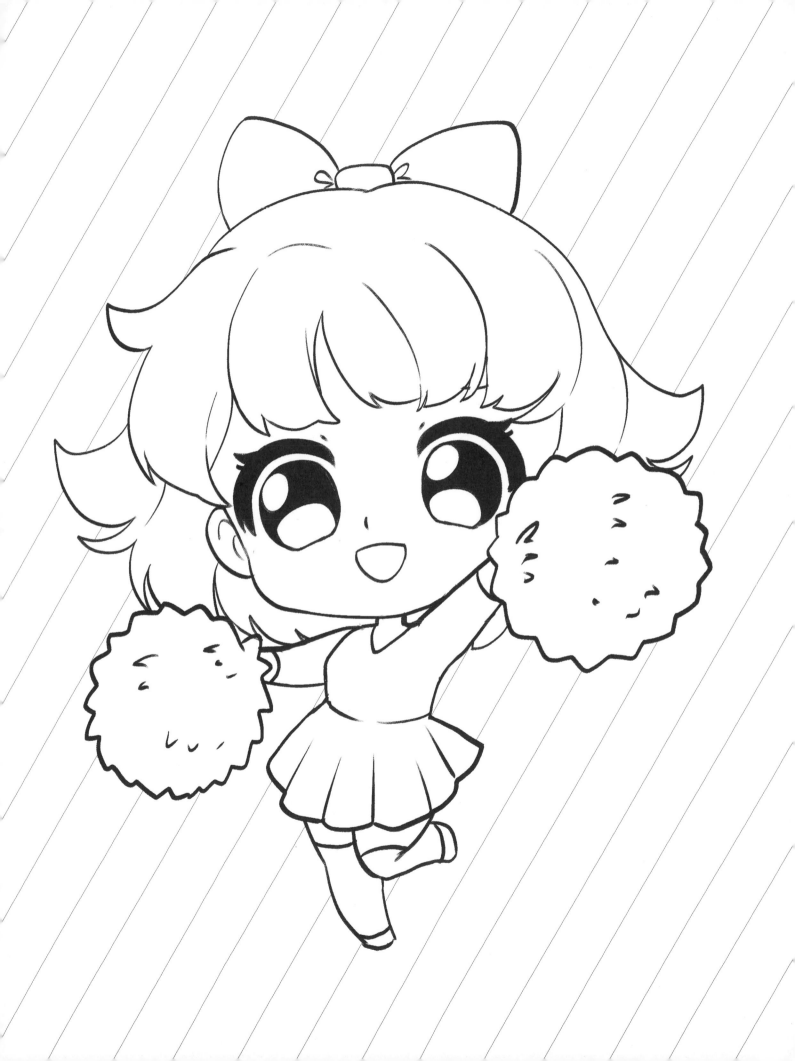

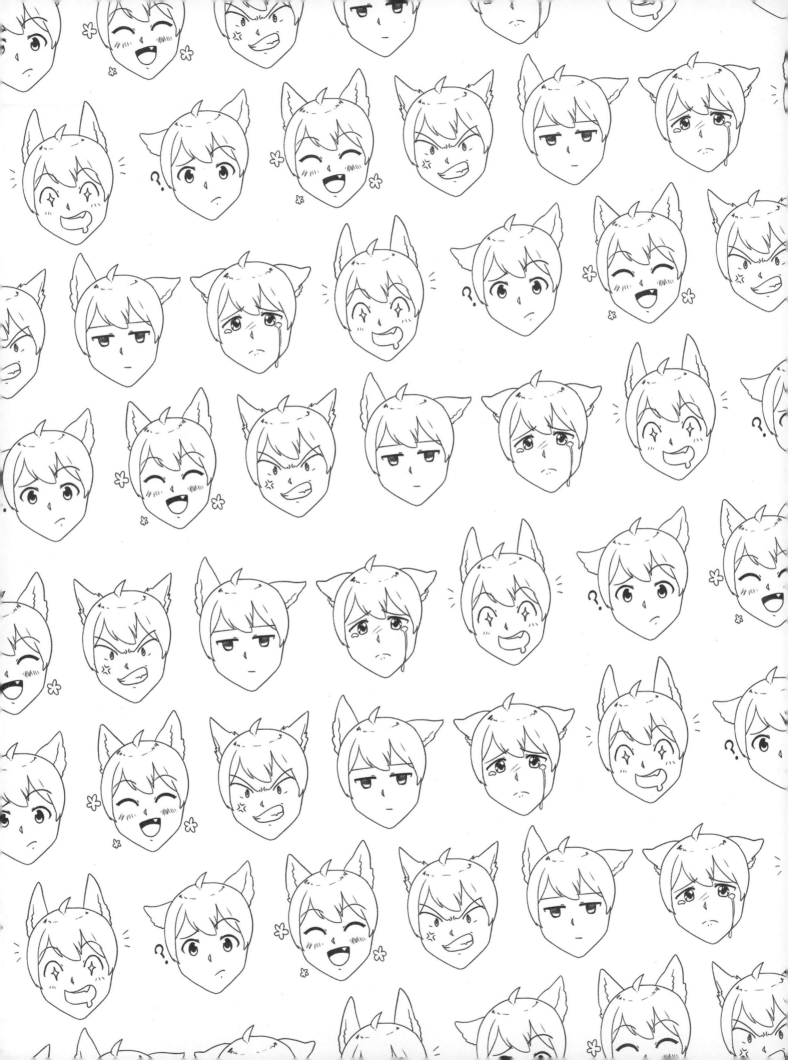

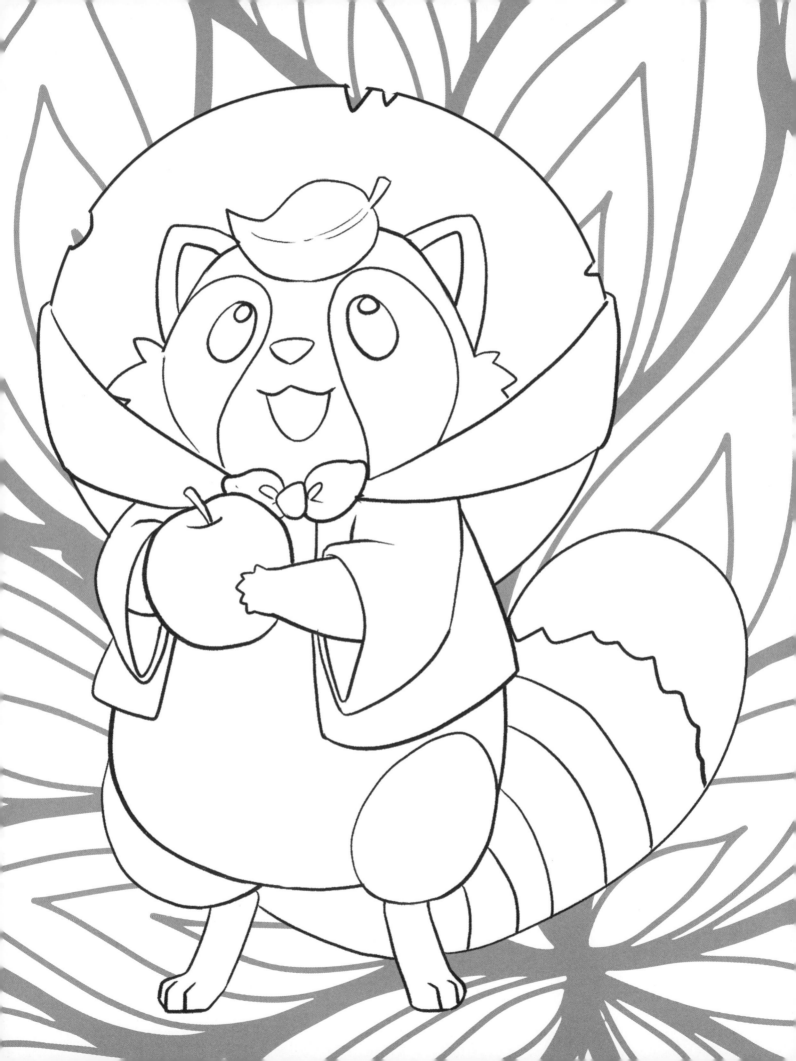

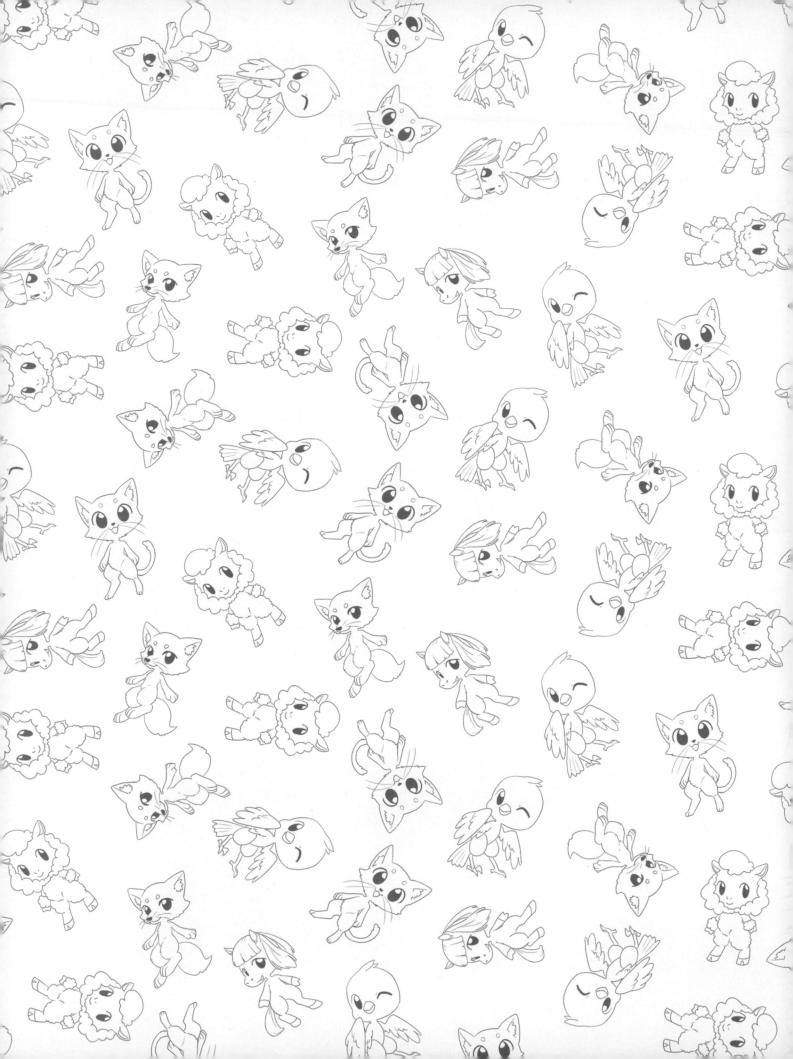

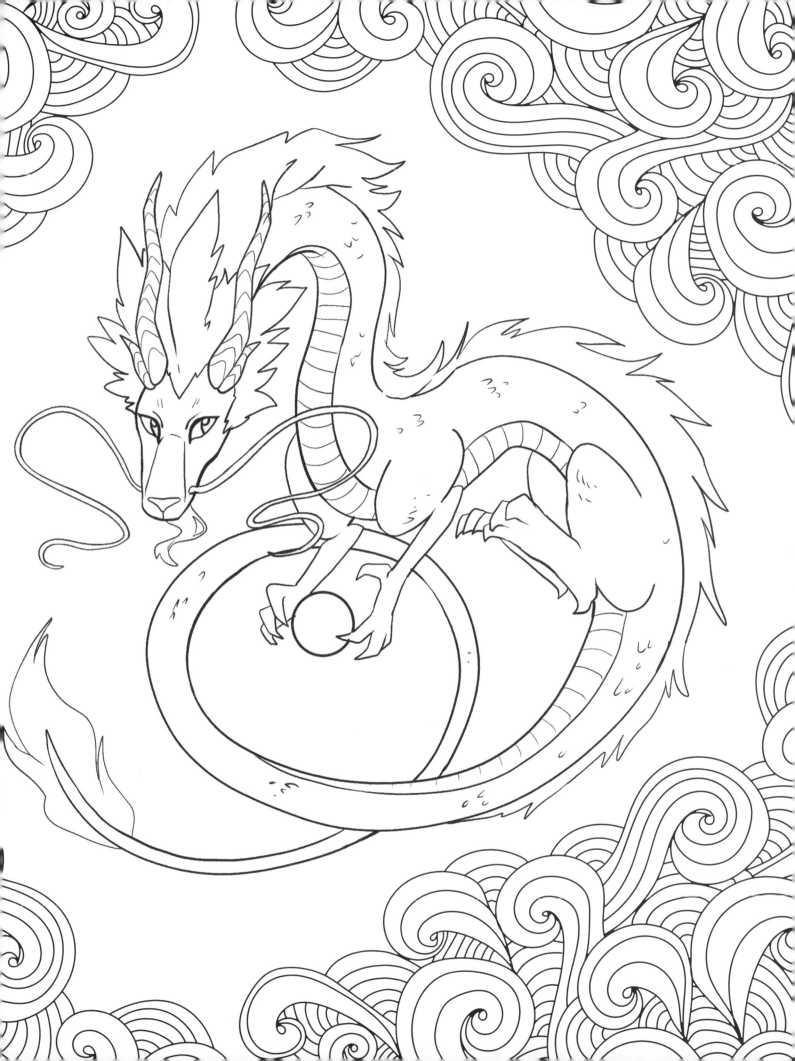

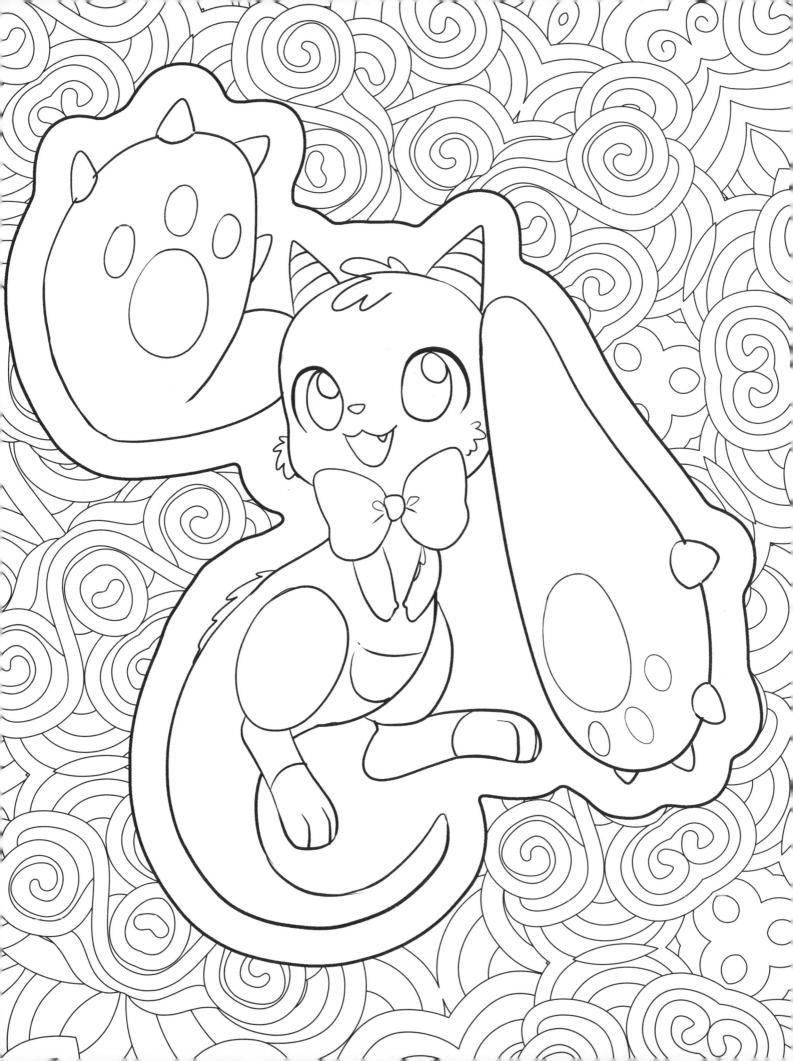

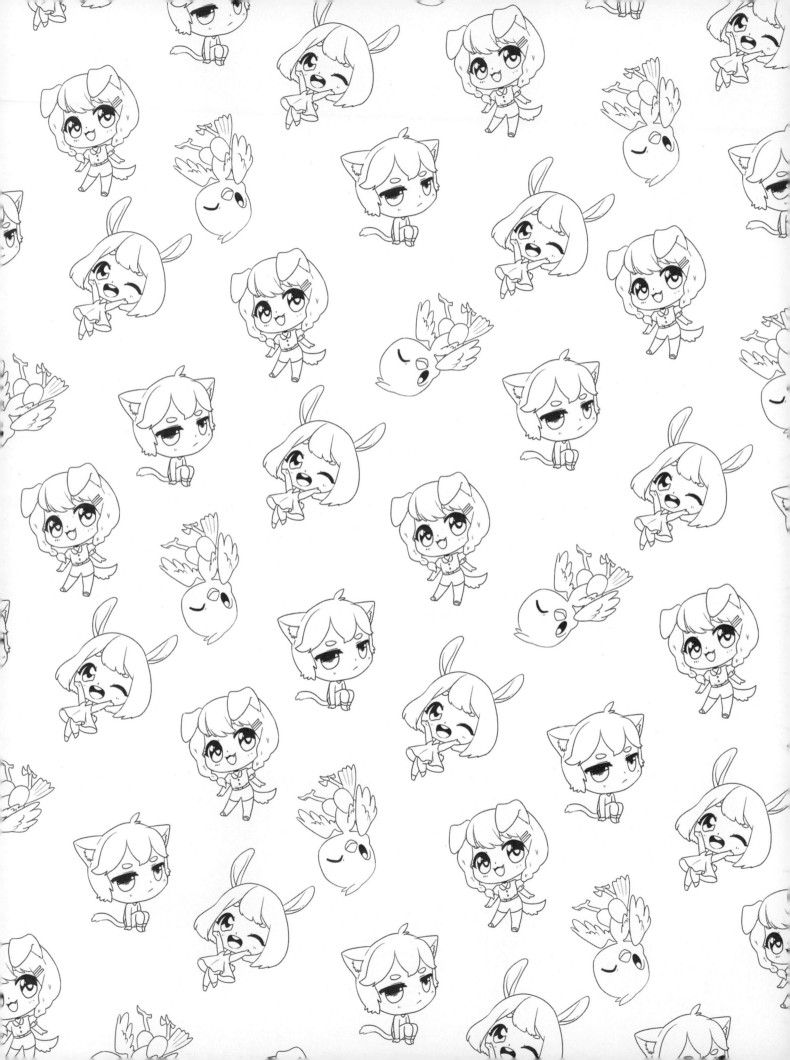

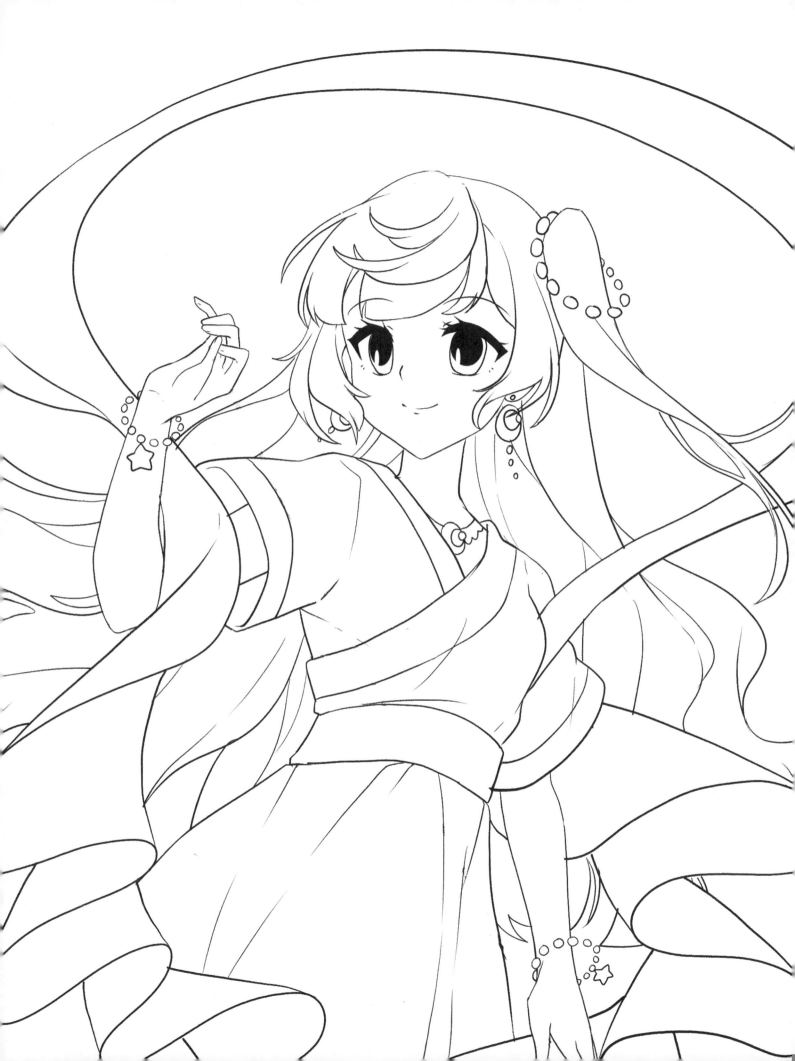

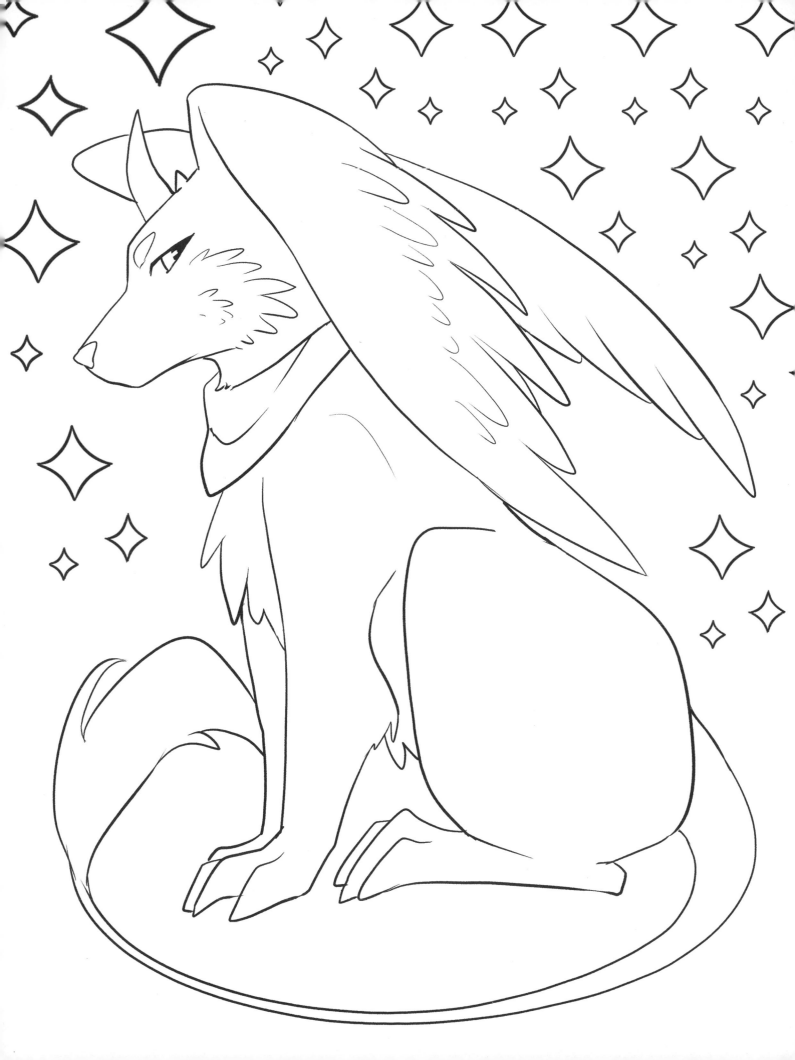

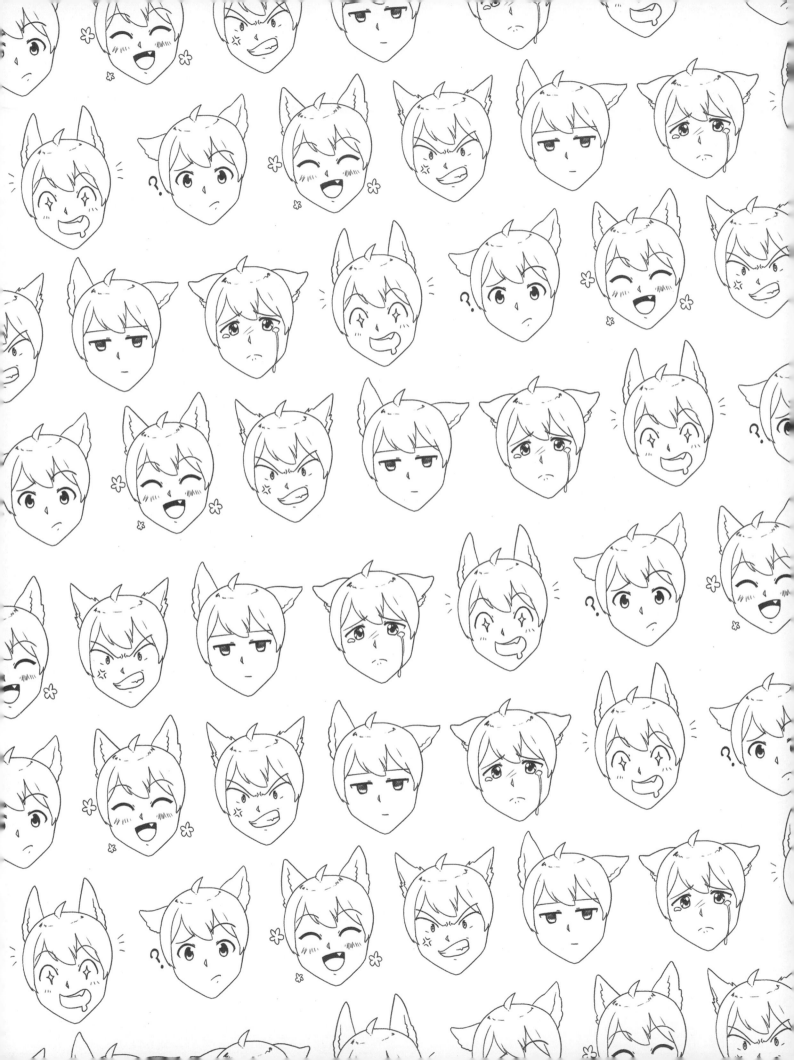

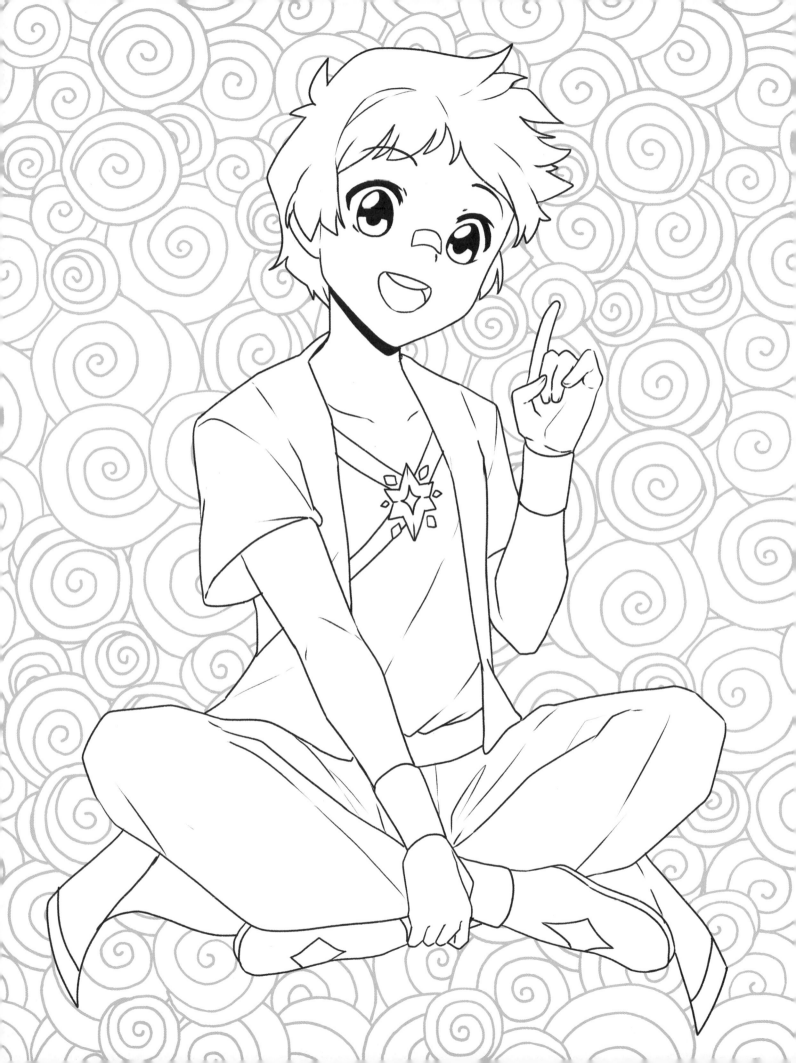

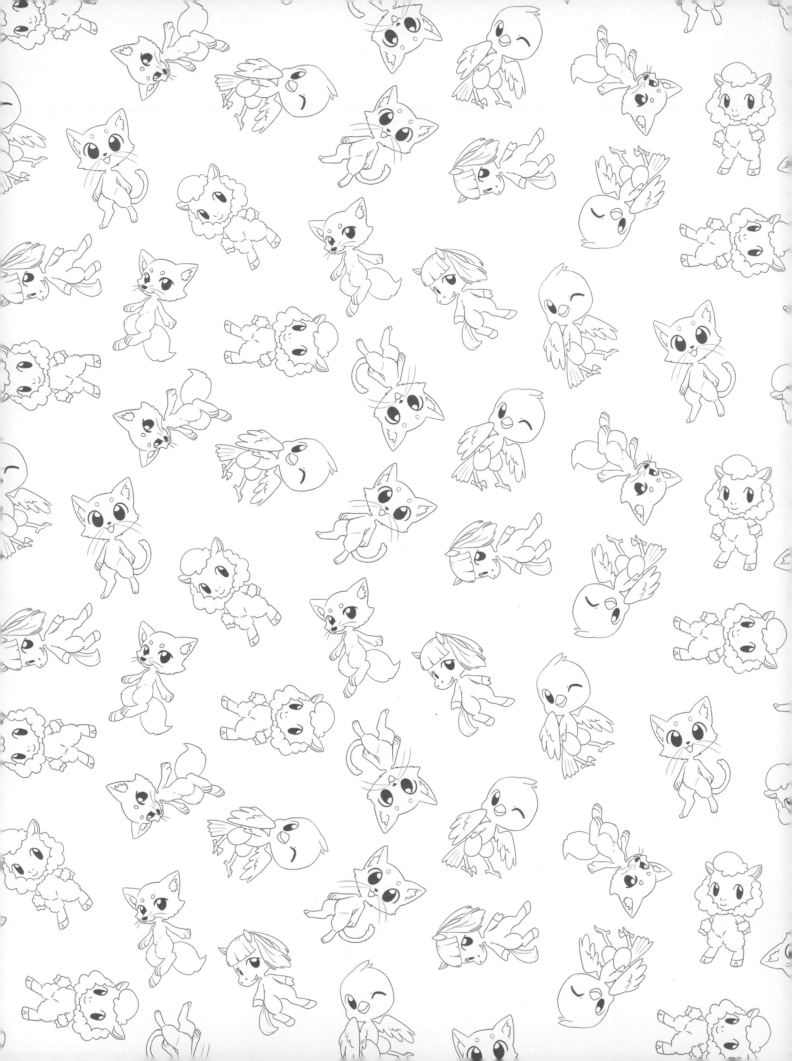

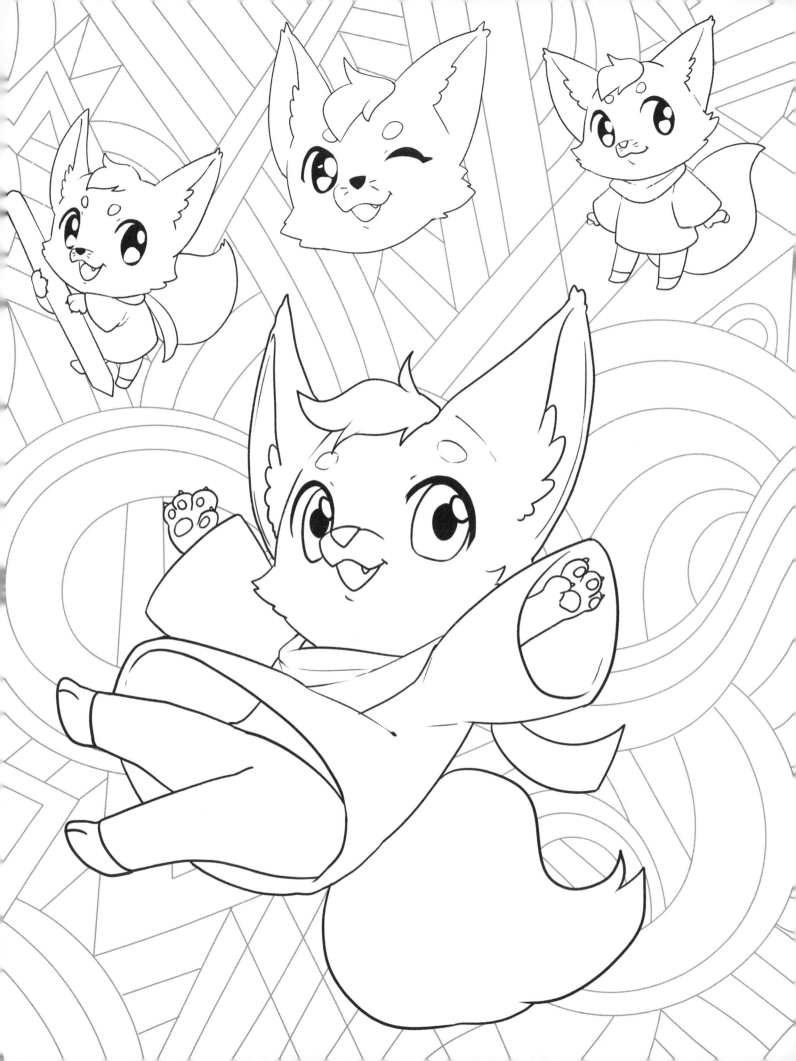

Brimming with creative inspiration, how-to
projects, and useful information to enrich your
everyday life, quarto.com is a favorite destination
for those pursuing their interests and passions.

First published in 2023 by Walter Foster Publishing, an imprint of The Quarto Group.
100 Cummings Center, Suite 265D, Beverly, MA 01915, USA.
T (978) 282-9590 **F** (978) 283-2742 **www.quarto.com • www.walterfoster.com**

Contains content from *The Art of Drawing Manga* (Walter Foster Publishing, 2022) and
The Art of Drawing Manga Furries (Walter Foster Publishing, 2023).

Walter Foster Publishing titles are also available at discount for retail, wholesale, promotional,
and bulk purchase. For details, contact the Special Sales Manager by email at specialsales@
quarto.com or by mail at The Quarto Group, Attn: Special Sales Manager, 100 Cummings
Center, Suite 265D, Beverly, MA 01915, USA.

ISBN: 978-0-7603-8496-1

Printed in China
10 9 8 7 6 5 4 3 2 1